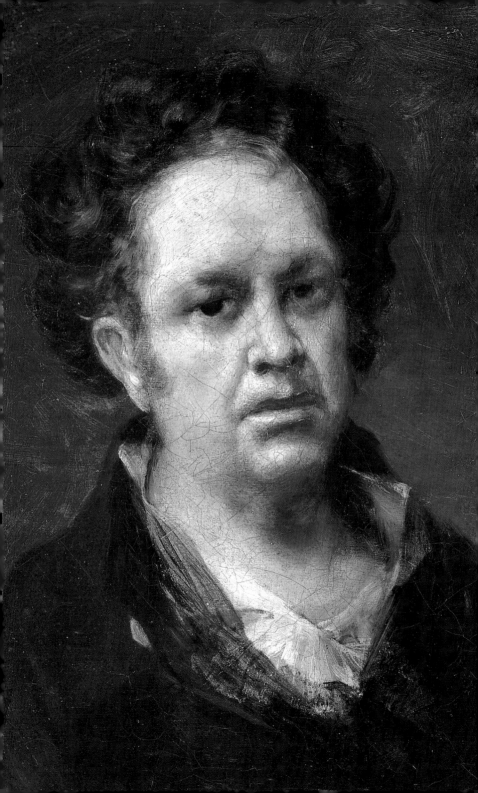

ArtBook Goya

DORLING KINDERSLEY
London • New York • Sydney • Moscow
Visit us on the World Wide Web at http://www.dk.com

Contents

How to use this book

This series presents both the life and works of each artist within the cultural, social, and political context of their time. To make the books easy to consult, they are divided into three areas which are identifiable by side bands of different colors: yellow for the pages devoted to the life and works of the artist, light blue for the historical and cultural background, and pink for the analysis of major works. Each spread focuses on a specific theme, with an introductory text and several annotated illustrations. The index section is also illustrated and gives background information on key figures and the location of the artist's works.

1746-1779

1780-1792

■ Page 2: Goya, *Self-portrait*, 1815, Museo del Prado, Madrid

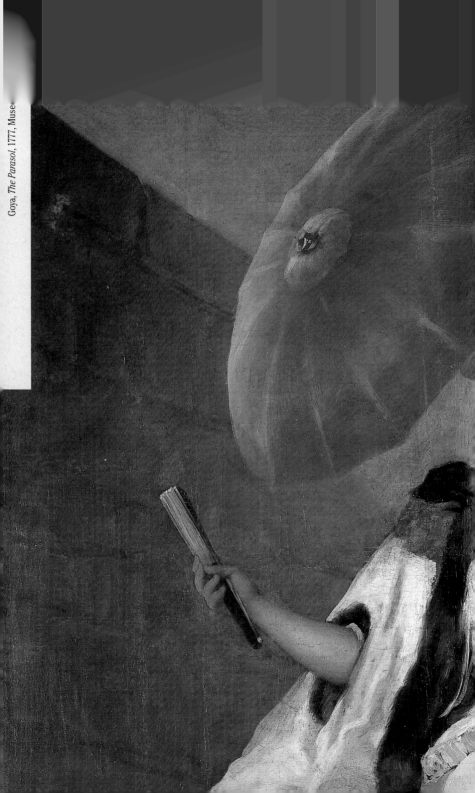

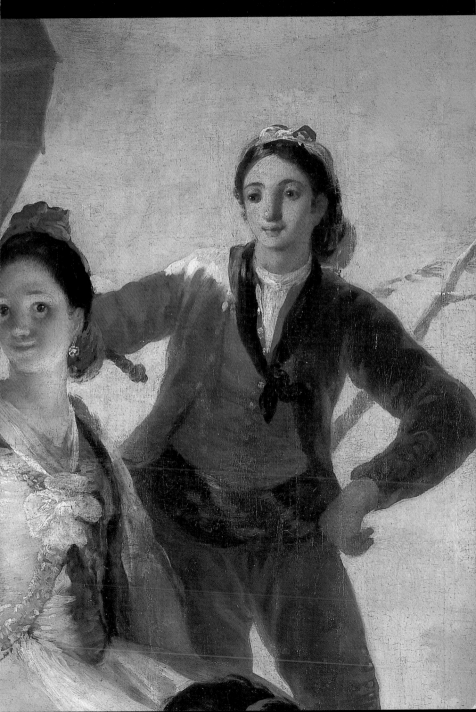

Early days
and dreams

From the provinces to the Academy

Francisco Goya y Lucientes was born on March 30, 1746 in Fuendetodos, a small rural village in the Aragon region of northern Spain. Although his maternal grandparents had been landed gentry, Francisco's father struggled to make a living as a master gilder, and the family lived a fairly circumscribed existence. In 1760 his parents returned to their home town of Saragossa and Francisco enrolled in a religious school there. It was here at the Escuelas Pias that he was to have his first taste of art and to meet Martín Zapater, a friend who would remain close to him all his life. The same year, when Goya was fourteen, he was apprencticed at the studio of Saragossa's master painter, José Luzan Martinez. There he learned to perfect his drawing skills by endless copying of engravings. His humble origins were of little use in opening doors to the glittering world of art and artists, but his stubborn and determined character was, and helped to sustain him through his first failed attempt at entering the Royal Academy of San Fernando in Madrid in 1774. He tried again in 1776, submitting a piece on a historical theme, and again failed. After this we know little about his life although it is likely that he became a pupil of Francisco Bayeu, a successful painter at the Spanish Court.

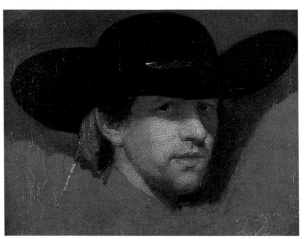

■ *Portrait of a Man with a Hat*, 1773–75, Museo de Bellas Artes, Saragossa. Mystery surrounds this beautiful unfinished work. Some claim it is a self-portrait by Goya as a young man; others maintain that it is the portrait of an unknown man, painted by Francisco Bayeu.

■ The Goya family lived at number 18 Alhondiga Road, in the village of Fuendetodos, deep in the Aragon countryside.

■ Goya, *The Apparition of the Virgin of el Pilar to Santiago of Compostela and Images of the Saints*, 1762. The paintings were executed for a shrine in the basilica of El Pilar in Saragossa.

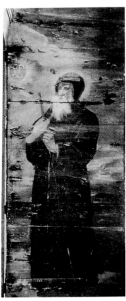

■ The humble birthplace of the artist. The house belonged to Goya's mother's family, who were of aristocratic if impoverished stock. Goya's father, a gilder by trade, was always poor.

■ Our Lady of el Pilar, Saragossa's cathedral, was a magnificent church of vast and spectacular dimensions. It was erected in honour of the Virgin Mary. Goya was to work there as a young man.

BACKGROUND

Europe in the throes of change

Europe went through a period of great transition in the mid-eighteenth century. The Austrian Wars of Succession came to an end in 1748. In Spain, Philip V of Bourbon died, succeeded in turn by Ferdinand VI and Charles III. It was mainly the latter who was to effect radical change on Spain's capital city, inviting numerous foreign artists to his court. Among the prestigious names were Sabatini, architect and pupil of Vanvitelli; Anton Mengs, father of Neoclassicism; Tiepolo, the brilliant Italian exponent of Rococo. In the first half of the century archeological discoveries at Herculaneum and Pompeii fuelled a passion for ancient art, while in the second half that passion was channelled and directed by the philosophy of the Enlightenment. How modern this period seems when we consider the social and political upheavals that were taking place. In 1748 Montesquieu published *The Spirit of Laws*; in 1762 Rousseau wrote *The Social Contract*; in 1763 Voltaire wrote *A Treatise on Tolerance*. Science, philosophy and industry underpinned the new Europe, which in the middle of the century had a population of more than 140 million. In 1763 came the discovery that the Earth was flattened at each pole; in 1756 the chemical element of carbon anhydride was isolated; in 1789 Lavoisier determined the composition of water and formulated the principle of conserving matter.

■ Anton Rafael Mengs, *Charles III*, 1761, Museo del Prado, Madrid. Mengs, a distinguished portrait painter, was appointed First Painter to the King in 1762.

■ A plate from the *Encyclopédie* of D'Alembert and Diderot, 1751, showing a camera obscura, one of the great scientific inventions which became a tool for artists.

■ Anton Rafael Mengs, *Parnassus*, 1760–61, Villa Albani, Rome. This fresco is considered the foundation stone of Classicism. The artist pays homage to Raphael, abandoning the Baroque style.

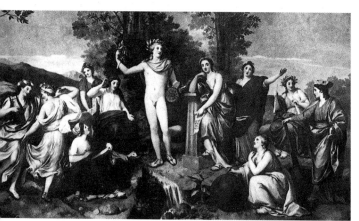

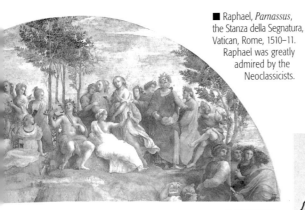

■ Raphael, *Parnassus*, the Stanza della Segnatura, Vatican, Rome, 1510–11. Raphael was greatly admired by the Neoclassicists.

■ Antonio Vivaldi (1678–1741). This great Italian composer died a few years before Goya's birth. Among the most influential musicians of the century, his interpretation of the *concerto grosso* remains strikingly modern.

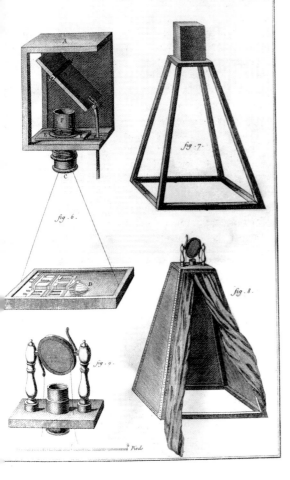

fig. 7.

fig. 6.

fig. 8.

fig. 9.

2 Pieds

The Encyclopedia

The first volume of the *Encyclopédie*, a massive work conceived as a dictionary of arts, sciences and professions, was published in Paris in 1751. Notwithstanding the condemnation of Pope Clement XIII, it was completed in 1772 boasting 17 volumes of text and 11 volumes of tables. It was the brainchild of a number of enlightened thinkers, coordinated by the philosopher Diderot and the mathematician D'Alembert. The most conservative members of society bitterly opposed the project, which was nevertheless one of the greatest achievements of the modern age.

11

New role models in Italy

owards the end of 1769 Goya departed for Italy, possibly accompanied by Mengs who was heading for Rome. It was actually in Rome that the young Goya spent much of 1770 engaged on a number of mythological paintings. From there he sent the work entitled *Hannibal Contemplates Italy from the Alps* for a competition at the Academy at Parma. The piece did not win, but gained an honourable mention and much critical acclaim for the artist. When Goya registered for the competition he described himself as "a pupil of Francisco Bayeu" and the records list him as being Roman. He evidently chose to disclaim his real teacher in preference for his father-in-law, his senior by twelve years, whom he knew to be much favoured by the Spanish court. Bayeu combined the Neoclassicism of Mengs with Tiepolo's loose and joyous approach, the two styles most valued at that time. There was, however, another master to whom Goya was greatly indebted – his fellow Spaniard Diego Velázquez (1590–1660). Goya had first discovered his work while under José Luzan's apprenticeship, and had devoted himself to copying many of the paintings of his extraordinary predecessor. Velázquez was renowned for the commanding presence of his paintings. His cultured style harked back to classical times while displaying elements which were entirely his own.

■ Johann Joachim Winckelmann, *The History of Ancient Art*, 1764. This work propounded the "noble simplicity and tranquil greatness" of Greek art and generated much thought and discussion.

■ Ivanov Anton Ivanovic, *View of the Roman Capitol*, 1848, Saint Petersburgh, Russia. The palaces of the Conservatori, the Capitoline Museum and the Senatorio face the square. Rome was at the forefront of the cultural revolution.

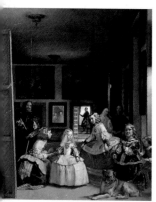

■ Diego Velázquez, *Las Meninas*, 1656, Museo del Prado, Madrid. This late painting depicts the King of Spain's young daughter. Velázquez is at his easel.

■ Diego Velázquez, Self-portrait, detail from *Las Meninas*, 1656, Museo del Prado, Madrid. Velázquez, seen here with a proud and satisfied expression, was one of Goya's favourite artists.

■ Goya, *Francisco Bayeu*, 1795, Museo del Prado, Madrid. Here the artist copied a self-portrait by his father-in-law, who died that year. It was exhibited soon after in Madrid's Royal Academy.

■ Goya, *Hannibal Contemplates Italy from the Alps for the First Time*, 1770–71, private collection. This sketch was done for the painting which he submitted to the Parma Academy. Sadly, the actual painting has been lost. The sketch was later returned to Goya.

Changing tastes

The end of the Seven Years' War did not bring about any great changes in Europe. However in 1748 the Hapsburg Maria Teresa was crowned empress, and her appearance on the international scene heralded enormous changes, culturally as well as politically. In terms of art, as one style waned, another was born and blossomed. While the last glimmers of Rococo were vanishing, Neoclassicism was springing up in every field of art. Johann Joachim Winckelmann, German by birth and Roman by upbringing, was the most important theorist of the period and can be viewed as the founder of Neoclassicism in art. As early as 1755 he published *Thoughts on the Imitation of Greek Art* in Dresden, in which he maintained that imitation does not imply a sterile form of copying, but rather a source of inspiration, a way of working involving heightened sensibilities. His later *History of Art among the Ancients* is the first of a series of texts which form the basis of modern art-historical studies. In 1769 the Scotsman James Watt invented the first steam engine; a new era was on its way.

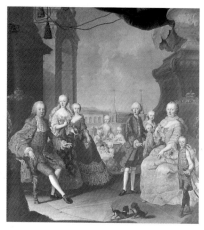

■ Martin van Meytens, *The Emperor Francesco I and the Empress Maria Teresa with their Family on a Terrace in Schönbrunn*, 18th century, Kunsthistorisches Museum, Vienna.

■ Jean-Honoré Fragonard, *The Crowning of the Lover*, 1771, Frick Collection, New York. A pupil of Boucher, Fragonard is one of the last heirs to the explosive exuberance of the Baroque.

■ Madrid's Royal Palace (Palacio Real) was built on the site of the ancient Austrian castle of Alcazar. It was started in 1738 and completed in 1764.

■ Angelica Kauffmann, *Johann Joachim Winckelmann*, 1764, Kunsthaus, Zurich. The German archeologist and art historian is considered the precursor of the esthetic movement.

■ Giambattista Tiepolo, *Apotheosis of Spain*, 1765, throne room, Palazzo Reale, Madrid. The wash of blue and extraordinary perspectives make this vast ceiling appear to merge int the sky. Tiepolo was a master at bringing allegorical stories to life with a panoply of classical characters.

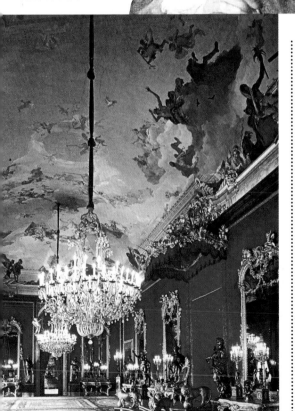

Tiepolo in Madrid

Giambattista Tiepolo (1696–1770) is considered one of the greatest European artists of his time. A series of major works in Italy and abroad brought him international fame, and in 1762 he went to Madrid, where he spent the last years of his life. There his luminous and joyous style of painting brought him countless honours and awards. As well as his frescoes for the royal palace, Tiepolo was commissioned to do seven altarpieces for the palace of Aranjuez. Tiepolo was as skilled a draughtsman as he was as painter. His style married sumptuousness with the liveliest aspects of theatre decoration, breathing life into mythological subjects by having them shine down on us from limitless skies.

Forays into religious painting

LIFE AND WORKS

■ Goya, *The Baptism of Christ.* An X-ray of this painting reveals the great care which Goya took with his brushstrokes to create his characteristically luminous effects.

In June 1771 Goya returned to Saragossa, already able to support himself as an artist. He was asked to submit sample work to decorate the small choir of the Cathedral of El Pilar and produced a vast number of sketches and ideas. He finished the definitive draft in January 1772 and the final fresco that same June. It is a large work in which angels sit or hover among gently billowing clouds The luminous sky pays homage to Tiepolo while the broad brushstrokes are reminiscent of Corrado Giaquinto, a Neapolitan artist who was painter at the Spanish Court from 1753 to 1762. Goya's painting was well received and won him other commissions, for example the *Fathers of the Church* for the nearby parish at Remolinos, as well as a number of private commissions. In just a short while he had become sought-after throughout the city. After Tiepolo's death in 1770, Francisco Bayeu gained an even more secure foothold within the Spanish Court, a position which he strengthened via his prolific output. At that point the marriage between his sister Josefa and Goya guaranteed the ambitious young painter from Fuendetodos the recognition he longed for. Given the older artist's acceptance of the marriage, it is unlikely that Goya was the flighty, unreliable ladies' man that certain biographers have claimed. With this union with the family of Bayeu, it seemed that Goya's climb to success was well under way.

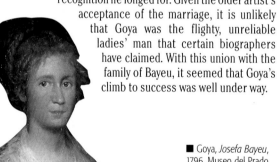

■ Goya, *Josefa Bayeu*, 1796, Museo del Prado, Madrid. In July 1773, Francisco Bayeu's sister married Goya. It was to have a limited influence on the life and work of the artist.

■ Drawing from page 12 of Goya's Italian sketchbook, in which he made notes about Florentine Renaissance art, which he admired greatly.

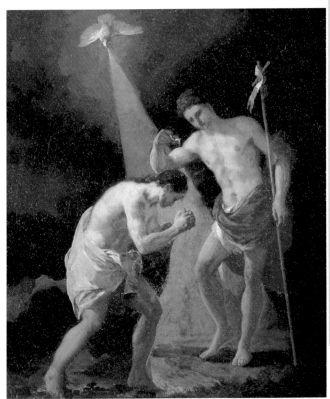

■ Goya, *The Baptism of Christ*, c. 1775–80, collection of Count Orgaz, Madrid. This painting, which vibrates with light and heat, shows how Goya has not forgotten the lessons he learned a few years earlier from Italian Renaissance art.

■ Goya, *Adoration in the Name of God*, 1772, small choir in the Cathedral of El Pilar, Saragossa. This large fresco, measuring 7 by 15 metres, was executed in a matter of months.

■ Anton Rafael Mengs, *Charles III as Hunter*, 1786–88, Museo del Prado, Madrid. The German-born Mengs was renowned for his skill in capturing the essence of his subject, and for his powerful compositions. Here he leaves the landscape relatively bare, using it as a backdrop for the king.

Saint Joseph's Dream

This fine oil painting comes from a series of
seven executed by Goya for the chapel of the
palace of Sobradiel in Saragossa. He finished
in it 1771 and it is now on display in the city's
Museo de Bellas Artes.

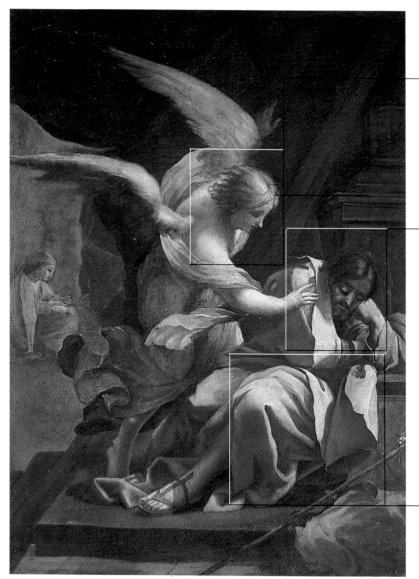

■ The archangel Gabriel's face has a softness and sweetness to it as he delivers his message to Joseph about the mystery of the conception. His body is defined by a series of curves which spiral down from his shoulders and chest.

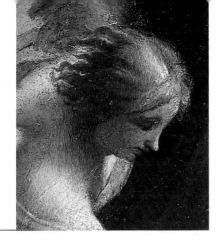

■ Unaware of the presence of the archangel at his side, Joseph sees him in a dream. He will wake from his sleep happy, free from the doubts about Mary's honesty. Here Goya has skilfully rendered the figure: the play of lights and shadows pulls Joseph out of the darkness while revealing the structure of the architecture behind him. The composition is based on a work by the French artist Simon Vouet.

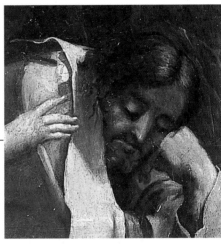

■ Joseph's coat encircles and protects him. The folds which hang from his knee appear both as genuine cloth and as a raiment made entirely of light. Here as in the other paintings in this series, Goya has drawn inspiration from 16th- and 17th-century Italian and French art.

From Francisco Bayeu to the Royal Tapestry Factory

Goya's late twenties marked a period of intense productivity. He undertook an ambitious commission for the Monastery of Aula Dei on the outskirts of Saragossa, executing eleven works in oil about the life of Christ and the Virgin Mary. Completed in 1774, they display an ever-more uniform and limpid use of color. Shortly after that, Goya moved to Madrid. He was summoned there by Mengs, First Painter to the King, who had recently reorganized the Royal Tapestry Factory at Santa Barbara and wanted Goya to join a group of young artists working there. Like the others, Goya was to supply cartoons – full-scale paintings that the weavers copied exactly in wool. He was to work under the supervision of his brother-in-law, Francisco Bayeu, and the family links may well have played a part in this latest commission. Between 1775 and 1791 Goya supplied no fewer than 63 cartoons destined for the royal residences. However, notwithstanding the importance of Madrid's weaving industry, Goya was troubled that his paintings were put to a practical use. Nevertheless, by October 1775 he completed his first series of cartoons, based on Charles III's two great passions, hunting and fishing, which were to hang in the dining room of the Escorial, the palace of San Lorenzo.

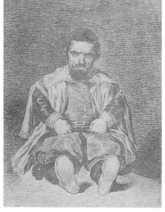

■ Goya, *The Parasol*, 1777, Museo del Prado, Madrid. This cartoon was for the dining room of the Pardo Palace, residence of the Prince of Asturias. It was to hang above a doorway. Goya consequently located the couple on a hill-top, to create a sense of heightened perspective, and lit up the backcloth.

■ Goya, *Sebastian de Morra*, etching, 1778. Goya produced a series of prints after Velázquez; it was common at the time to study and emulate the master.

■ In the 19th century Goya's etched copper-plates were coated in steel to protect them. This particular etching is based on a painting by Velázquez in which the court jester is shown as both dignified and powerful.

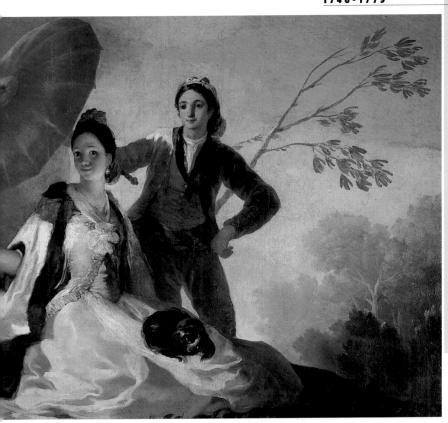

■ Goya, *Pope Innocent X*, 1780, private collection, Madrid. There were still valuable lessons to be learned from the great Diego Velázquez.

■ Diego Velázquez, *Pope Innocent X*, 1650, Galleria Doria Pamphilj, Rome. Here the virtuoso use of colour serves to highlight the character of the pontiff.

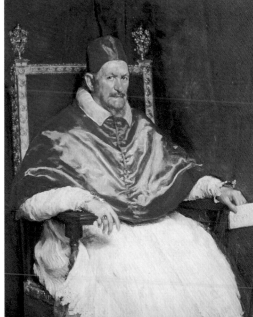

The eighteenth century: luxury, war, and religion

The eighteenth century saw the flourishing of the decorative arts: fabrics and tapestries, furniture and fittings, plaster and wooden figurines, mirrors and jewels, glass and ceramics, gemstones and ivory. The exponential growth which took place over a period of ten years matched the growth in disposable income of the moneyed classes. The magnificence of eighteenth-century homes was visible throughout Europe, from Spain to the West as far as Russia. Artists and artisans of the day moved easily from one country to another, exporting their craftsmanship to an eagerly awaiting market. War was always at hand, the ruling dynasties for ever setting their sights on political and commercial expansion. The desire for the control of trade set armies into motion by land and by sea; occasionally the signing of a truce or forming of an alliance brought the hostilities to a halt. But in Europe, peace and liberty remained far-away dreams. The Catholic world entered a period of crisis from which it never fully recovered: the tenets on which its power rested collapsed. In 1773 Pope Clement XIV abolished the Company of Jesuits, already banned in France and Spain, and in 1776 the United States made their historic Declaration of Independence.

■ Cuciniello's nativity scene, Museo di San Martino, Naples. By the 18th century, Neapolitan nativity scenes were among the most important exponents of the applied arts. By bequeathing this splendid example to the museum, the owner hoped to inspire the creation of an 18th-century ambience there.

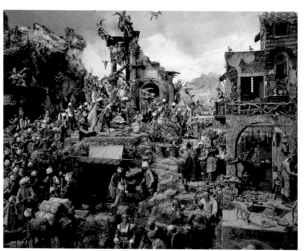

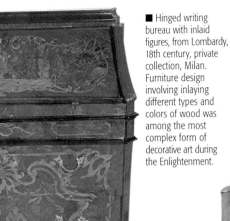

■ Hinged writing bureau with inlaid figures, from Lombardy, 18th century, private collection, Milan. Furniture design involving inlaying different types and colors of wood was among the most complex form of decorative art during the Enlightenment.

■ A. van Westerhout, *Gian Paolo Oliva*, engraving, 1751, from *Portraits of the Provosts of the Company of Jesus*.

■ Venetian gown in damask of green silk with pink stripes, 1775–80, Palazzo Mocenigo, Venice, Centre for the Study of Fabric and Fashion.

■ J. Neilson, *Vulcan Presents Venus with the Weapons made for Aeneas,* Gobelins tapestry, 1775, private collection.

The Washerwomen

Goya painted this cartoon in 1779–80 while engaged in
a series of works for the Pardo tapestries. It reveals his
growing interest in the landscape and his concern with
capturing the freshness of the scene. The painting is
now in the Prado Museum.

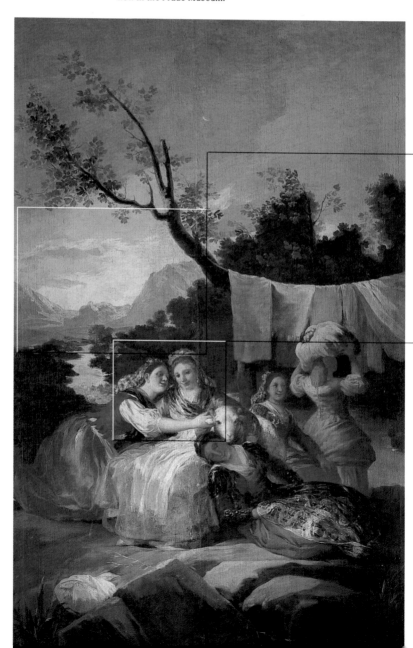

■ In this detail, a large slash of light-colored sky rips though the blue which itself has layers of lighter and darker tones. The green of the vegetation in the foreground creates a tonal contrast to the blue while adding to the sense of perspective. The scene is illuminated by the sunshine glimmering on the mountains.

■ In this sketch (1778), with its loose and easy rendering of forms, Goya had already arrived at the composition he desired for the final painting.

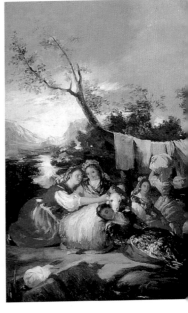

■ There is a liveliness and spontaneity in the faces of these women as they rest after their labours, and a look of tenderness as one reaches across the other to caress the sheep. They are the picture of happiness and serenity, and women such as these often featured in Rococo art. The flushed cheeks of the two women stand out against the pallor of their skin. Their hair is tied back in a style typical of the day. Their shawls, waistcoats, blouses, and gowns are all of the brightest colors, and add to the light-hearted mood.

Entry into the Royal Academy

Goya's production of cartoons for tapestries served him well. Lively, colorful, and perfectly balanced, they were considered masterpieces. In the meantime Anton Mengs' death in Rome in 1779 meant that there was an opening at the Academy of San Fernando; Goya put himself forward for it. He submitted *Christ on the Cross* which won him the unanimous approval of the Academicians, and he thus made his triumphant entry into Madrid's prestigious temple of art. His new-found fame, however, was swiftly followed by humiliation. His brother-in-law Bayeu deemed an enormous fresco which Goya had painted for one of the domes of Saragossa's Cathedral of El Pilar "unfinished", and Goya had no option but to repaint it. His pride was "burning him alive" as he wrote to his good friend Martin Zapater, but fate once again intervened. The King, impressed by Goya's many religious paintings, commissioned him to paint one of the seven panels for the church of San Francisco el Grande in Madrid. He was one of several artists chosen by the King, another of whom was Bayeu. It was now time for his brother-in-law to swallow his pride.

■ Diego Velázquez, *Christ on the Cross*, 1631, Museo del Prado, Madrid. Here, the combination of dark background, warm tonal colors, and the intensity of the scene create a masterpiece of the highest order.

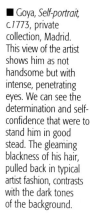

■ Goya, *Self-portrait*, c.1773, private collection, Madrid. This view of the artist shows him as not handsome but with intense, penetrating eyes. We can see the determination and self-confidence that were to stand him in good stead. The gleaming blackness of his hair, pulled back in typical artist fashion, contrasts with the dark tones of the background.

■ Anton Rafael Mengs, *Christ on the Cross*, 1761–69. The figure of Christ, whose upturned face is clearly in pain, is silhouetted against a backdrop of transcendent light.

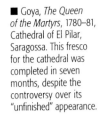

■ Goya, *The Queen of the Martyrs*, 1780–81, Cathedral of El Pilar, Saragossa. This fresco for the cathedral was completed in seven months, despite the controversy over its "unfinished" appearance.

■ Goya, *Christ on the Cross*, 1780, Museo del Prado, Madrid. Goya submitted this piece in the hope of being accepted as a member of Madrid's Royal Academy. In it he consciously married the styles of the great Velázquez and his own distinguished contemporary, Anton Mengs. While the painting itself is unexceptional, it nevertheless met all the requirements of the Academicians and won their unreserved approval.

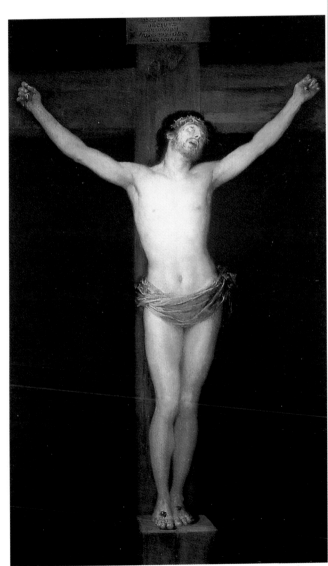

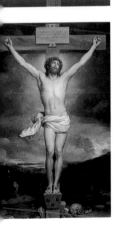

From Neoclassicism to Romanticism

B y the second half of the eighteenth century, the effects of the Enlightenment started to be felt in Spain, setting into motion a series of social and economic changes. During the reign of Charles III, the population grew by eleven million, agricultural and commercial productivity rose significantly, and cultural life started to flourish. The first literary circles became established in Madrid. Europe was in a state of transition from Neoclassicism to Romanticism, both products of the Enlightenment which placed the highest value on the individual and argued man's right to explore two areas long overlooked – feelings and reason. By this time the vogue for doing the Grand Tour had become popular. Partly as a matter of fashion, partly on a quest for knowledge, a broad spectrum of people visited Europe's capital cities and feasted on the richness of their heritage.

■ The Italian Ugo Foscolo (1778–1827) was one of the greatest European writers of the time. In 1815 he left his home-town of Milan to embark on a self-imposed, albeit controversial, period of exile in Austria, eventually ending his days in London.

■ Commedia dell'arte masks, 18th century, Museo Teatrale alla Scala, Milan.

■ Angelo Inganni, *Teatro alla Scala*, 1852, Museo Teatrale alla Scala, Milan. The visionary Neoclassical architect Giuseppe Piermarini designed the Scala, one of the world's greatest opera houses, to satisfy the cultured citizens of Milan.

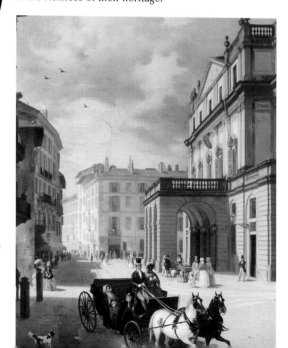

■ Anton Rafael Mengs, *Self-portrait*, 1771–77, Accademia Ligustica di Belle Arti, Genoa. This is one of the most interesting self-portraits of the period, with its rich psychological intensity. Mengs learned to draw very young; between 1741 and 1750 he travelled repeatedly to Rome to study the city's ancient offerings. His knowledge of Winckelmann's writings was of enormous significance in his own work.

■ Henry Fuseli, *The Nightmare*, 1781, Detroit Institute of Arts. A young girl lies sleeping and a monster – the embodiment of a nightmare – crouches malevolently on her chest. Fuseli often drew inspiration from legends or superstitions. Here his imaginative and grotesque painting captures the full terror of a nightmare.

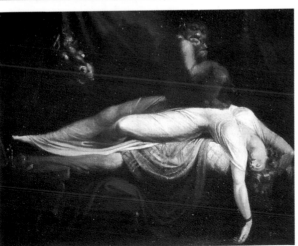

Important portraits, personal happiness

Goya's family was growing: between 1775 and 1782 Josefa bore five children. Then in December 1784 a son Javier was born, the only one of the children who would outlive his father. Goya, now in his early thirties, was starting to make a name for himself. Among his influential patrons were Count Floridablanca, powerful and dangerous alter ego to the king, and the Infante Don Luis, brother of King Charles III; in 1781 alone, Goya executed sixteen works for him. Although busy with these portraits, Goya had not given up his religious painting. In the spring of 1781 he worked on the pendentives for the Cathedral of Saragossa. At the end of 1784 he finished the vast altarpiece for the Church of San Francisco el Grande, a considerable undertaking given its size and the fact that it was a royal commission. These were critical years for Goya in which he laid the foundation stones for his future fame. When Anton Mengs died in 1779, he applied for the vacant position of First Painter to the King, but his petition was rejected. He had to champ at the bit for a while longer.

■ Goya, *Fortitude*, 1781, Cathedral of El Pilar, Saragossa. This fresco is one of four pendentives in the dome above the northern nave, each of which depicted a moral virtue. The style, with its loose overlapping brushstrokes, was considered radical at the time and evoked much negative criticism.

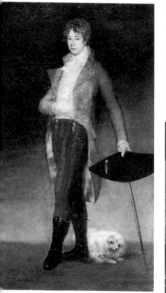

■ Goya, *Javier Goya and Bayeu*, 1805, private collection, Paris. His family portraits were equally remarkable.

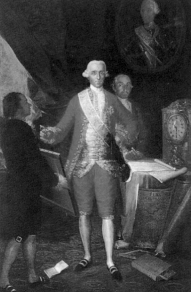

■ Goya, *Count Floridablanca, with Goya and the Architect Francisco Sabatini*, 1783, Banco Urquijo, Madrid. Notwithstanding the elegant composition, the painting is overly formal and the play of light unconvincing; the Count appears painfully static.

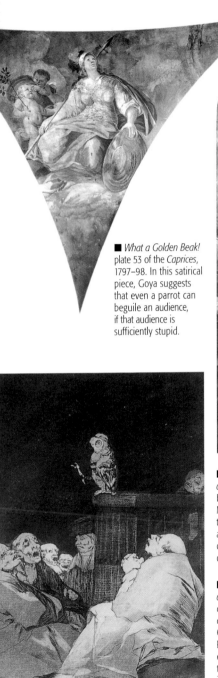

■ *What a Golden Beak!*
plate 53 of the *Caprices*,
1797–98. In this satirical
piece, Goya suggests
that even a parrot can
beguile an audience,
if that audience is
sufficiently stupid.

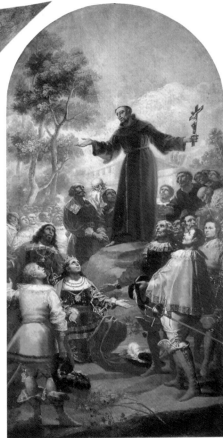

■ Goya, *St Bernardine
of Siena*, 1782–83, San
Francisco el Grande,
Madrid. The artist spent
two years on this work
and succeeded in
creating a lively sense
of space and depth.

■ Goya, *The Family
of the Infante Don Luis*,
detail, 1783, Mamiano
di Traversetolo,
Collection of Magnani
Rocca, Parma. Goya's
extraordinary attention
to detail is evident
in the skilful handling
of facial features.

The Family of the Infante Don Luis

This large oil painting, executed in 1783, shows enormous promise and is among the most successful of Goya's early works. It is housed in the collection of Magnani Rocca in Parma.

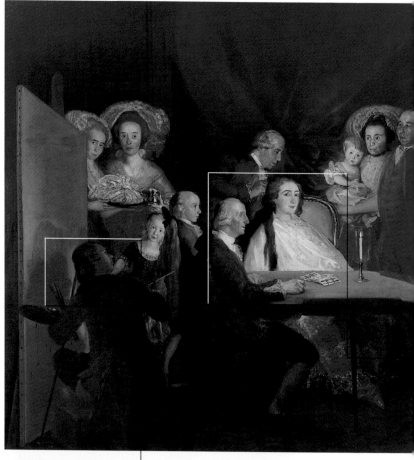

■ Goya painted this group portrait while he was staying with the Infante in the Arenas de San Pedro. The presence of the candle suggests that it is an evening scene, as the family gathers together

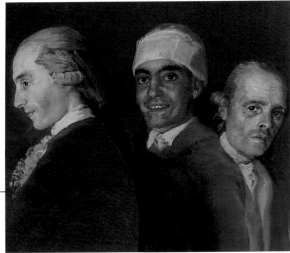

■ Don Luis and his wife appear relaxed with each other, despite their difference in age. Maria Teresa's informal garments lend an air of intimacy to the scene, and their whiteness draws our attention to her seated figure. A year or so after the painting was completed, the Infante Don Luis died, robbing the artist of a much needed patron.

■ Family, friends, and servants fill the canvas, and each is rendered with the same degree of accuracy and attention to detail. To the extreme right are two of Don Luis' servants, one of whom is wearing a wig held "under powder", as was the custom of the day.

around the card table. We see the artist from behind, poised in front of the canvas. As he looks towards the group, he attracts the attention of Don Luis' young daughter, who watches him inquisitively.

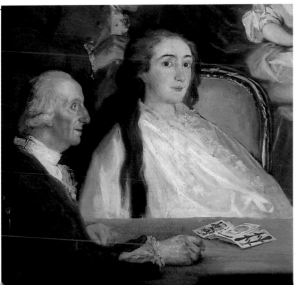

A growing fame

Among Goya's greatest talents were the ability to alternate between the "official" style of painting and a far more personal one, and his mastery of so many techniques. These qualities were to pay dividends when, in 1785, he was elected Deputy Director of Painting at the Royal Academy. Goya was already showing signs of being unwell, but his star was in the ascendant. With his other brother-in-law, Ramón, he was appointed Painter to the King. There was now a powerful immediacy in many of Goya's works, notably in his handling of children. He made them come alive, whether they were striking formal poses, playing games, or in mischievous mode. The subject of children was always close to Goya's heart, perhaps because he had lost four of his own in infancy. But there was another theme which captured his imagination and that was monsters – dark menacing beings, who made their first appearance in the background of his painting *San Francesco Borgia* (1788), for the cathedral of Valencia.

■ Goya, *But He Broke the Pitcher*, plate 25 of the *Caprices*, 1797–98. The urchin is punished, but it seems excessive. Goya is clearly moved by the boy's vulnerability, and his brilliantly realistic handling of the scene makes us share his sense of outrage.

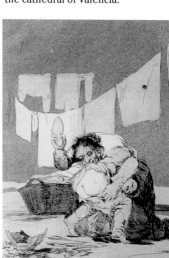

■ Goya, *The Duke and Duchess of Osuna with their Children*, 1788, Museo del Prado, Madrid, This family scene has everything – children, parents, toys, and even a little dog.

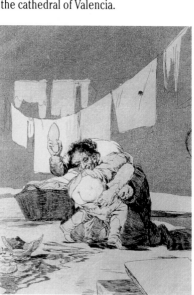

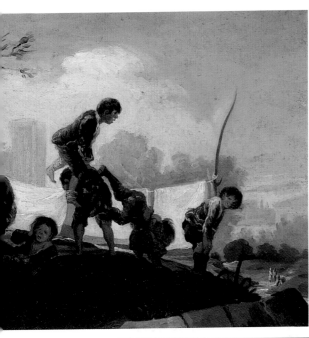

■ Goya, *Children's Games. Playing Leap-frog*, 1780, Museo de Bellas Artes, Valencia. This scene forms part of a nucleus of six small works in oil, which received considerable critical acclaim and were frequently copied. Goya may have conceived the subject matter after finishing similar tapestry cartoons in 1778.

■ Goya, *Winter*, 1786–87, Museo del Prado, Madrid. Goya treated his subject matter with striking realism. This work forms part of a series for the dining room of the Pardo Palace. In Goya's world, nature was often less than kind.

■ Goya, *The Annunciation*, 1785, private collection, Cordoba. This sensuous image was painted for the Convent of the Cappuchins of Saint Anthony of the Prado, Madrid.

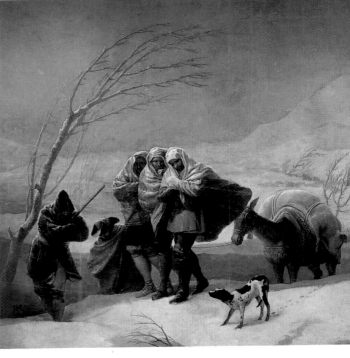

The final splendors of a dying century

Caserta, the Royal Palace of the Bourbons near Naples, was built a century after Versailles. It is just one example of a European architectural vision which is so varied that it defies a simple classification. The Spain at the time of the new King Charles IV (1788) went through a number of phases. Art and taste played a considerable part in shaping the national character; the ruling classes wanted to embellish their homes with *objets d'art* and styles of decoration that reflected wealth and splendour, as was the fashion on the Continent. The Spanish colonies were influenced by the cultural climate of their motherland, while at the same time developing their own indigenous style. Towards the end of the century, Goya's voice was pre-eminent in his native Spain; he returned to the deep roots of realism, so long shunned by the frivolity of the Rococo movement. Expanses of green, long considered the preserve of private residences, became part of the popular imagination and culture. And with this awareness of grass and greeness came a new-found reverence for Nature.

■ Caserta, the gardens of the Royal Palace, latter half of the 18th century. The fountain of Diana and Acteon (1779–89) juts out from the first level, carved in Carrara marble. In the far distance is the royal palace, started by Vanvitelli for the Bourbon kings in 1750.

■ Giuseppe Piermarini, *Palazzo Belgiojoso*, 1772–81, Milan. This is one of Italy's most important palaces, with its two inter-communicating courtyards and lavishly elegant interiors.

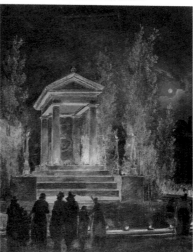

■ Hubert Robert, *The Cenotaph of Jean-Jacques Rousseau in 1774*, Musée Carnavalet, Paris. Robert, a distinguished French landscape painter, pays homage to one of Europe's greatest philosophers.

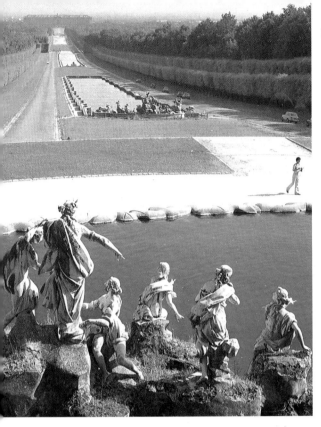

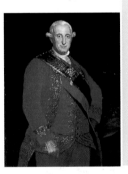

■ Goya, *Portrait of Charles IV*, 1789, Academia de Historia, Madrid. A mixture of haughtiness and bashfulness, this portrait was purchased by the Prado Museum in 1847.

■ Jacques-Louis David, *The Oath of the Horatii* 1784–85, Musée du Louvre. David's painting typified the sentiment of the age and was considered a manifesto for Neoclassicism. He painted it while in Rome studying classical art.

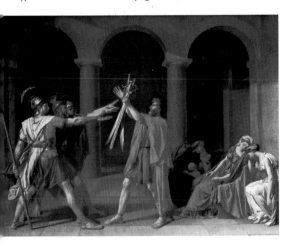

Jacques-Louis David

David (1748–1825) is one of the central figures of Neoclassicism. He was fascinated by 17th-century Bolognese artists and by classical sculpture, which he had studied first-hand during his visits to Italy. As well as his bent for antiquity, he was very much involved in the politics of the age and was an ardent supporter of Napoleon. Indeed David was appointed Napoleon's official painter and was responsible for the many images which have served to immortalize him. His years immediately following the French Revolution were particularly fertile ones in which he painted numerous outstanding portraits.

The Meadow of Saint Isidore

Drawn mainly from life, Goya executed this in 1788 for the room of the young princes at the Pardo Palace. Like its counterpart, *The Hermitage of Saint Isidore*, it has a luminosity which anticipates the painting of the 1800s.

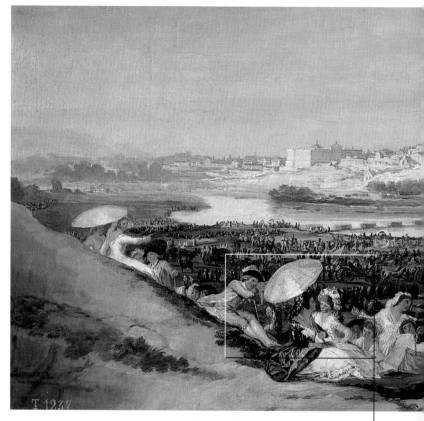

■ It is May 15: people have gathered along the banks of the Manzanares river to celebrate the anniversary of Saint Isidore. The ever-charming *majas* rest under parasols, enjoying the attentions of the elegant young men.

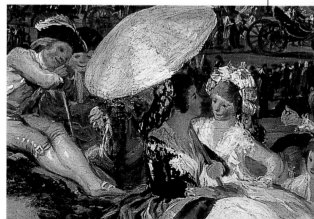

■ Buildings often
feature in Goya's work.
Here Madrid's majestic
architecture creates
a focal point in
the distance.

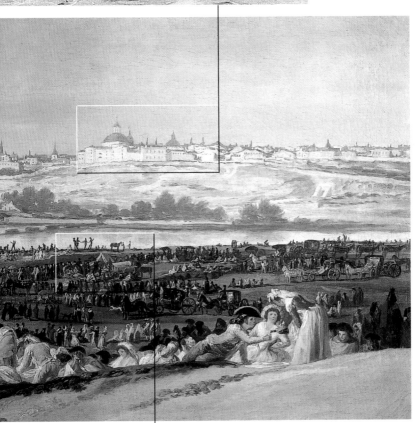

■ Goya's mastery at its
best – swarming figures,
a flash of color, and
a sense of movement
created by a few
perfect brushstrokes.

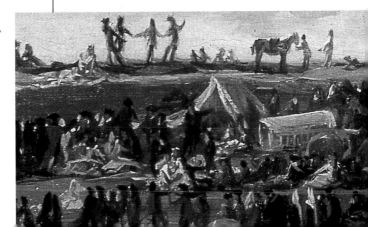

The final cartoons and other masterpieces

The last series of cartoons, which by royal request were to be "rustic and gay", was delivered during the course of 1792. It consisted of *The Straw Manikin*, *The Wedding*, and *The Stilts*. Times were changing and the death of their "enlightened" king, Charles III, took its toll on the Court and on the Spanish people. The future king and queen requested Goya to paint some portraits of them in preparation for the Coronation (January 17, 1789). Goya undertook these commissions with great thoroughness while not neglecting his other paid work or giving up his own particular passion – drawing scenes of bullfights. But Goya the man was changing. Outside events, political as well as personal, were affecting him deeply. In particular his illness, which had started some years earlier, was becoming ever-more insistent. He had a particularly bad spell while he was working in Cadiz, and was granted royal dispensation to go to Andalusia in order to convalesce. His friend Martin Zapater was informed on March 29, 1792 how serious the situation was, and that Francisco was likely to be deaf for the rest of his life.

■ Goya, *Maria Luisa*, 1789, Academia de Historia, Madrid. This is the *pendant* of Charles III's portrait, commissioned via his friend Jovellanos, for which Goya received six thousand Spanish *reales*.

■ Two pages from Goya's sketchbook, pen and ink, red and black chalk, Museo del Prado, Madrid. Always interested in the human form, the artist experimented with a vast range of poses and postures.

■ Giovan Battista Piranesi, *Whimsical Inventions in Prisons*, 1760–61. Piranesi drew inspiration from the Mamertine prison in Rome. His fantastical vision underlined an aesthetic concept known as "sublime", dominated by a sense of awe.

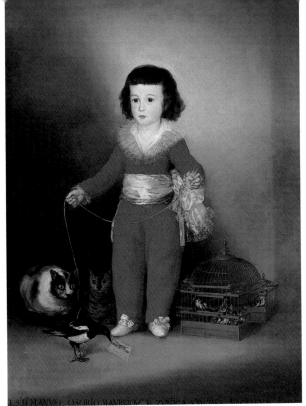

L.S.D MANVEL OSORIO MANRIQ^ DE ZVÑI^...

■ Goya, *Don Manuel Osorio de Manrique Zuniga*, 1788, New York, The Metropolitan Museum of Art. Goya captures the luminous delicacy of the boy's face in this tender portrayal of a child surrounded by his cherished pets. Don Manuel is the young son of the Count and Countess of Altamira, who bought several works by the artist.

■ *Goya, Scenes from a Prison (A Lunatic Asylum)*, 1816, Academia de San Fernando, Madrid. The physical pain and sense of isolation which now plague Goya find expression in his painting. Dark images of haunted, demented figures start to make an appearance in his work.

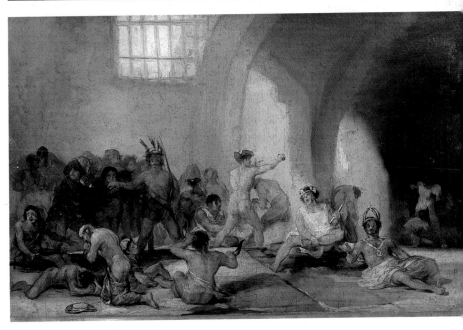

MASTERPIECES

The Wedding

Painted in 1792, this forms part of the last series of cartoons for the palace. It features a lively open-air scene with characters who know each other all too well. The tapestry was destined for the king's room at the Escorial.

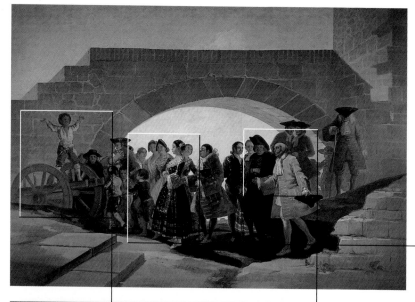

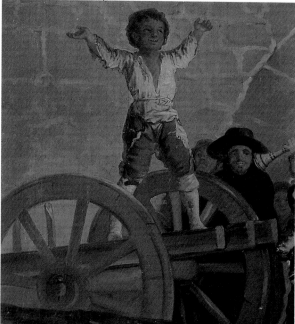

■ The street urchin plays about on the abandoned cart with a look of glee. He is confident and full of life, but little concerned with the events of the day. All that he and his friends care about is enjoying themselves. His ragged clothes are in stark contrast to the elegance, at times misplaced, of the guests who are arriving. The boy represents another splendid characterization of youth by the artist.

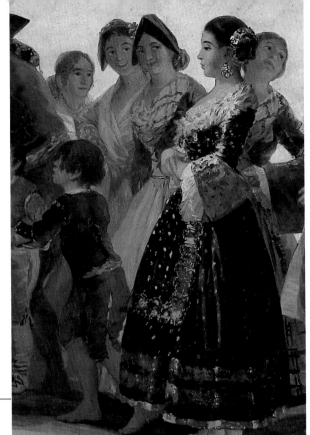

■ The portrayal of the female contingent of the group is brilliantly realised. Goya captures every detail of their clothing, and every nuance of their mixed expressions. The bride advances and the women crane to take a look, smiling and evidently moved by the scene. The young woman's beauty is heightened by the ugliness of the groom, but we are led to surmise that he is "a good catch".

■ The male figures are no less interesting than the female ones, for example the typical country cleric, evidently looking forward to the wedding banquet, or the elderly character who might be the bride's father, opening his arms in a gesture of self-satisfaction. Once again Goya displays his mastery of human expressions: no gesture is too small for him to notice; no nuance of character or physiognomy passes him by.

BACKGROUND

Turbulent years

On January 17, 1789 Charles IV came to the throne. He was forty years old and history would remember him as a weak and ineffectual king. In France, on July 14, 1789, a group of revolutionaries stormed the Bastille, Paris' infamous prison. It was the first act of a new era, and all of Europe was to be caught up in it. This was true even for Spain, which gradually saw the rise of a new social strata made up of a growing bourgeoisie – a middle class of small landowners, artisans, farmers, and workmen. This "revolution" was felt even in the fields of science and architecture. On the one hand there were new inventions and areas of research; on the other, utopian ideals applied to the structure of society. The most exciting innovations came from France and Great Britain. The architects of the new order held on to classical styles, but tended to combine them with a simplification of form, often set within a natural context. Alternatively, they arrived at working solutions for ways of living which were completely avant-garde, for example the project for the royal rooms of Claude-Nicolas Ledoux at Arc-en-Senans. The idea of the city as a unified system of functions and styles based on ever-changing needs of the inhabitants was born. The process of change had begun for real; all of Europe was waking up to it.

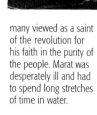

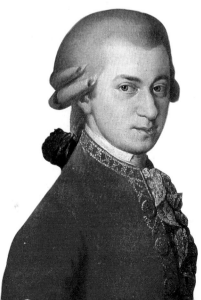

■ Wolfgang Amadeus Mozart, born in 1756, died in Vienna in 1791. His death marked the end of one of the most profound influences both on instrumental music and on music for the theatre.

■ Jacques-Louis David, *The Death of Marat*, 1793, Musées Royaux des Beaux Arts, Brussels. This timeless masterpiece of European art depicts a man who many viewed as a saint of the revolution for his faith in the purity of the people. Marat was desperately ill and had to spend long stretches of time in water.

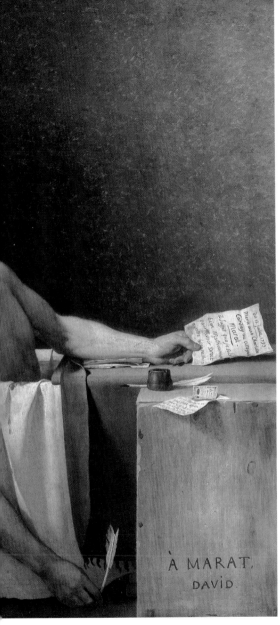

■ Jacques-Louis David,
Portrait of the Lavoisiers,
1788, Metropolitan
Museum, New York.
This portrait, stylistically
excellent, represents a
well-known couple in
the field of science.

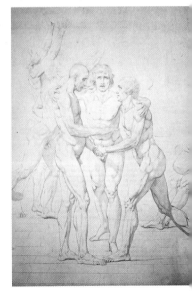

■ Jacques-Louis David,
The Tennis Court Oath,
(detail), 1791, Musée
National du Château,
Versailles. This work,
which never went
beyond preliminary
sketches, was dedicated
to the oath made by
the National Assembly
that they would not
dissolve until they
had ratified the
new Constitution.

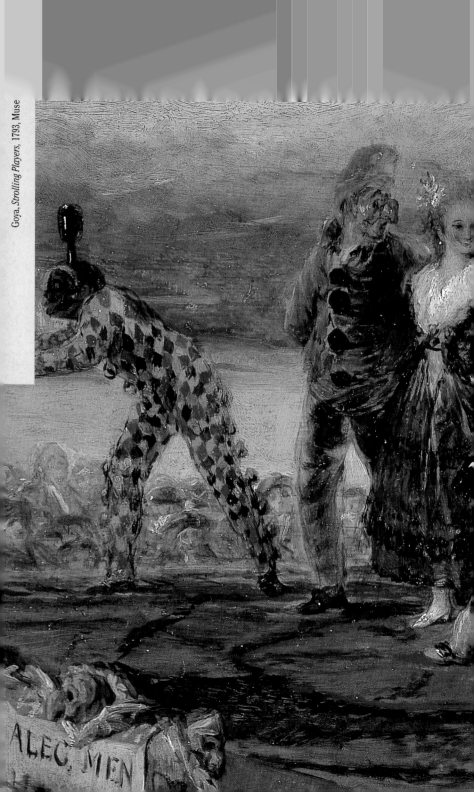

Goya, *Strolling Players*, 1793, Muse

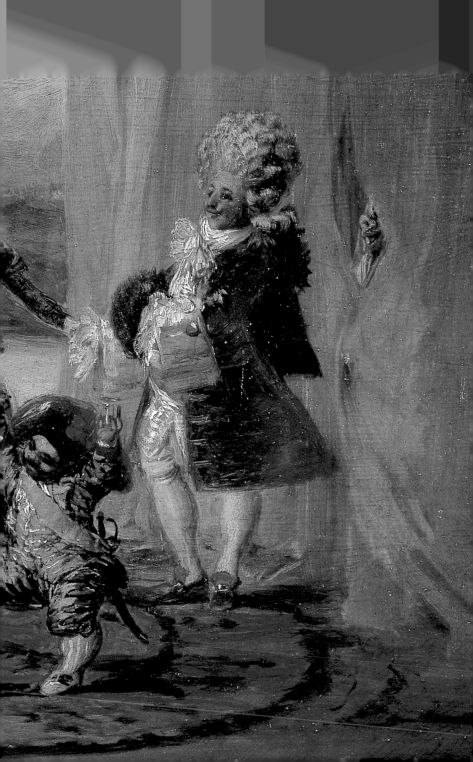

A struggle for life, and recovery

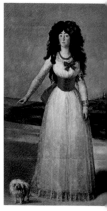

Goya's continuing ill health prevented him from working until the summer of 1793. He must have recovered by July 11 because he was present at a session of Madrid's Royal Academy on that day. To silence the rumours that his professional life was at an end, he delivered eleven small engravings to his friend Don Irarte the following January, explaining in a letter that he was able to give vent to thoughts and feelings within those images – works of whimsy and of the imagination – which had no place in commissioned works. Events conspired to help Goya: in 1795, after his brother-in-law died, he was elected Director of Painting at the Academy. He was now the most influential artist in Spain. There is a suggestion that he became romantically involved with the Duchess of Alba, one of his patrons, after the sudden death of her husband. His paintings of her are unquestionably among the most beautiful of all his works. He was to say of the Duchess that "there was not a hair on her head that did not arouse desire". Whatever the truth behind their relationship, the proud Francisco was already setting his sights on more dizzying heights.

■ Goya, *Maria Teresa Cayetana de Silva*, 1795, private collection, Madrid. Here the date and Goya's signature appear as though written in the sand. The artist has used strong contrasts of light and color to capture this Mediterranean beauty.

■ The Goya room at the Duke and Duchess of Alba's Liria Palace in Madrid. The artist's work lines the walls.

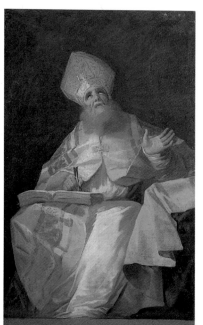

■ Goya, *Saint Augustine*, 1796–99, private collection, Madrid. It is uncertain where this fine painting was destined to go. Brilliantly executed, it forms part of a series of four *Fathers of the Church*.

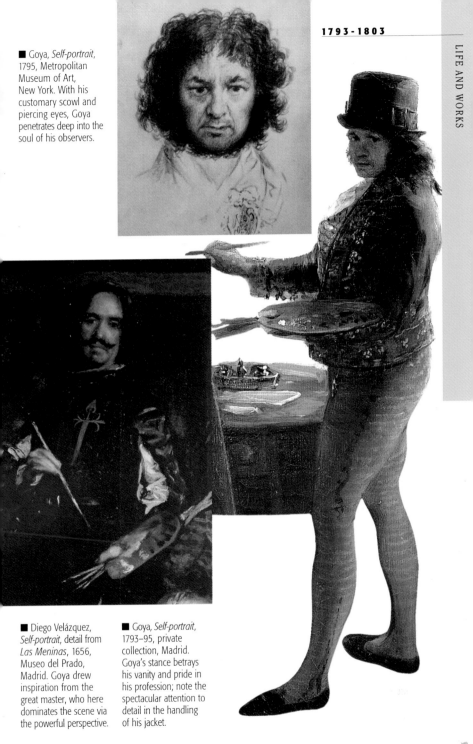

■ Goya, *Self-portrait*, 1795, Metropolitan Museum of Art, New York. With his customary scowl and piercing eyes, Goya penetrates deep into the soul of his observers.

■ Diego Velázquez, *Self-portrait*, detail from *Las Meninas*, 1656, Museo del Prado, Madrid. Goya drew inspiration from the great master, who here dominates the scene via the powerful perspective.

■ Goya, *Self-portrait*, 1793–95, private collection, Madrid. Goya's stance betrays his vanity and pride in his profession; note the spectacular attention to detail in the handling of his jacket.

The genius of European art

Canova, Ingres, Goya, and David are just four of the giants of this extraordinary period in time. In each of them artistic genius reached the highest form of expression. Their harmonious handling of form and color produced a style which was still essentially classical, but already there were the stirrings of a something new, something which sent echoes reverberating deep within the soul – these were the early glimmerings of Romanticism. While all of Europe had an eye to the future and was busy making preparations for the first public art galleries, philosophical and social arguments raged over the concept of beauty. In literature, those who believed in a classical style crossed swords with those who opted for a "modern" approach in one of the most impassioned debates of all time. The principle of "art for art's sake", with its intrinsic belief in the imagination over the intellect, was gaining its adherents.

■ Antonio Canova, study for *Cupid and Psyche*, c.1787. If the finished sculptures of Canova are considered perfect, no less so are his studies, works of art in themselves.

■ Goya, *Cupid and Psyche*, 1800–05, Museo de Arte de Cataluña, Barcelona. Here Goya gives vent to a highly personal interpretation of this familiar subject.

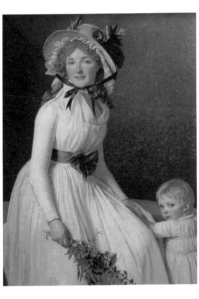

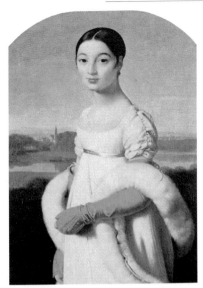

■ Jacques-Louis David, *Madam Sérizat with her Son*, 1795, Musée du Louvre, Paris. The style here is full of grace, tenderness, and sentimentality, a far cry from the usual treatment prevalent at the time.

■ Jean-Auguste Dominique Ingres, *Portrait of Mlle Rivière*, 1805, Musée du Louvre, Paris. The sensuous beauty of this "Empire-style" portrait displays a deep understanding of Italian classical renaissance art.

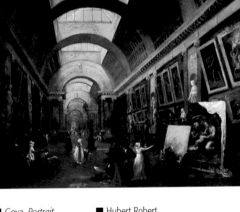

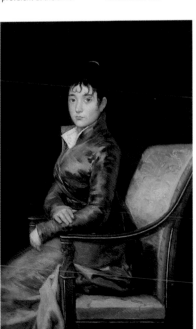

■ Goya, *Portrait of Teresa Sureda*, 1804–06, National Gallery of Art, Washington. In his portraits of women, Goya achieves a dazzling virtuosity.

■ Hubert Robert, *Setting up the Main Gallery of the Louvre in 1796*, Musée du Louvre, Paris. One of the first curators of the Louvre, Robert saw the museum as an instrument of social growth, with a responsibility for imparting lessons in history.

"The Tyrant"

Housed in Madrid's Academy of San Fernando, this portrait (1799) is of a famous actress, Maria del Rosario Fernandez. She received her nickname because her actor-husband frequently played the part of a tyrant.

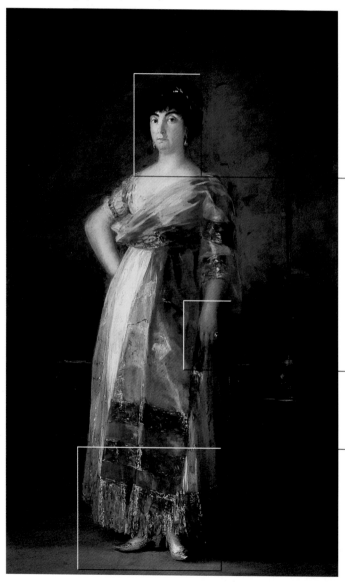

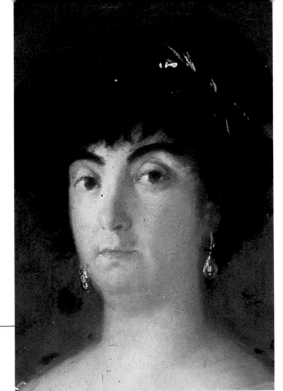

■ The actress' dark, raised eyebrows lend her a distinctly haughty air as she appears to size up her audience. The slender hair ornament which glimmers against her jet-black curls is complemented by her pearl drop earrings.

■ In the semi-darkness, Maria's hand seems to invite our caress. Her ring catches the light and adds to the allure of her soft, smooth skin. Goya's economical use of white draws our gaze to the ring and then back to Maria's earrings and the ornament in her hair. No longer young, she in nevertheless beautiful in her elegant outfit, and her imperious bearing implies that she knows it.

■ Goya's masterly handling of light and color is evident in the contrast between the sparkling gold threads and the luminous red fabric. The shoes with their long, pointed toes and low heels are typical of the fashion of the period.

55

Glory springs from invention

Goya's professional life was one of constant creativity. His suspected romantic interlude now over, he threw himself into his work with renewed passion. He resigned from the Academy because of his health, but still managed to complete the brilliant *Witchcraft* series for the Duke and Duchess of Osuna by June 1798. Sorcery and witchcraft were popular themes at the time, and Goya's handling of them seemed to follow on from his satirical *Caprices* prints of around the same period. After this, Goya returned to Madrid and started to draw his friends, all part of a liberal, intellectual circle. As well as being perfect characterizations, the portraits have enormous psychological depth. Goya, however, was weighed down by debts and so was forced to look for paid work. He took on the commission to paint the chapel of San Antonio de la Florida, an offer which he received largely due to the auspices of his friend, the statesman Jovellanos. The undertaking proved to be quite

■ Goya, *Miracle of St Anthony of Padova*, 1798, Hermitage of San Antonio de la Florida, Madrid. Situated on the Crown's land, the chapel did not come under the jurisdiction of the Church. Heedless of customary pictorial convention, Goya completed the work in just four months, and in so doing succeeded in creating one of the most innovative cycles of European art.

difficult, but Goya executed it with such freedom of expression that the result was unusually innovative. The miracle of St Anthony takes place amid a crowd of curious onlookers. Angels participate in Anthony's glory from all around the chapel – the dome, the arches, and the side walls. The spreading of the Word becomes almost filmic in its rendition. This setting is to be Goya's final resting place.

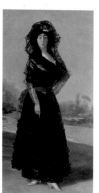

■ Goya, *The Duchess of Alba*, 1797, New York Hispanic Society. The words "Only Goya" are written on the ground, perhaps indicating a secret love for a proud and haughty woman.

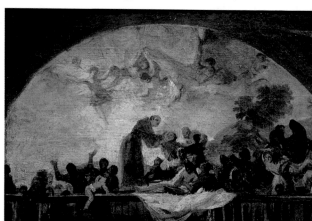

■ Goya, *Self-portrait* from the Frontispiece of the *Caprices*, 1797–98. The artist could not have depicted himself in a more demure pose here, although he still appears melancholy and somewhat troubled.

■ Detail of the fresco of San Antonio. Goya first traced the outlines of the drawing directly on the gesso, adding the color as a second layer.

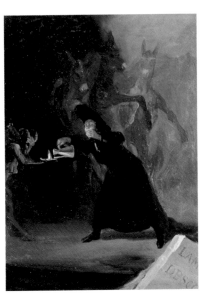

■ Goya, *The Devil's Lamp, (The Bewitched)*, 1797–98, National Gallery, London. This painting was inspired by a play by Antonio Zamora, Court Poet of the 18th century. Goya acknowledges his debt on the stone at the lower right-hand side of the picture.

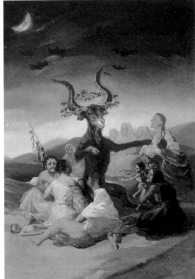

■ Goya, *The Witches' Sabbath*, 1797–98, Museo Lazaro Galdiano, Madrid. The old crones, followers of the he-goat, offer him small children for a ritual sacrifice.

■ Goya, *Ascensio Julia*, known as "El Pescadoret", c.1798, Thyssen Collection, Madrid. At the base on the left-hand side are written the words "Goya to his Friend Asensi", the artist's copyist and occasional assistant.

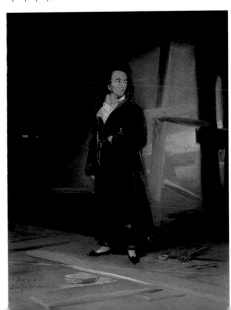

Past, present, and future

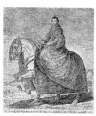

Inextricably linked, the past, present, and future were the main influences on cultural life. The past was the model on which to base oneself, although it soon had a limiting effect; the present was the proof of a day by day reality which in turn created an awareness of human existence; and the future was already the present because of the speed at which man had to adapt to changes in order to keep pace with current events. Consequently, man was projected even further forward in time, supported by a combination of science and faith in himself. Even the concept of God was changing – He was a completely new God. While politics was in transition from a monarchist to a state system, so art was moving from a refined, courtly style to the Romantic subjectivism of the middle class, passing through a period of Neoclassicism, which crystallized the basic concepts of Classicism itself. For artists like Tiepolo, Watteau, Vivaldi, and Mozart, the most important aspect of their work was to indulge the hedonism of their patrons. Goya, Leopardi, and Beethoven, by contrast, were artists who lived for themselves, adapting the prevalent styles of the day, searching for a personal idiom, and so often finding themselves at odds with the culture and ethos of the times.

■ The engravings which Goya made of the Spanish royals on horseback reveal a detailed understanding of the subject.

■ Goya, *The General José Rebolledo de Palafox*, 1814, Museo del Prado, Madrid. The Spanish general (1776–1847) fought bravely against the French.

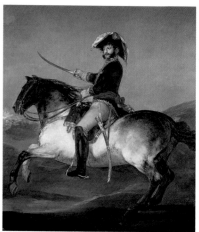

■ The *Perpetual Calendar – 1700/1992* of P. Diamandi, Paris. Many of the most bizarre inventions hailed from Paris.

■ *Filae*, a drawing by David Roberts, 1838–39. Following the Napoleonic campaign (1798), Egypt became part of the cultural circle and prompted a passionate interet in all things Egyptian.

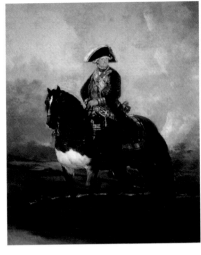

■ Goya, *Queen Maria Luisa on Horseback*, 1799, Museo del Prado, Madrid. The Queen's bearing is arrogant yet lacking in elegance as she sits astride her splendid horse, Marcial, a gift from her favoured minister Manuel Godoy.

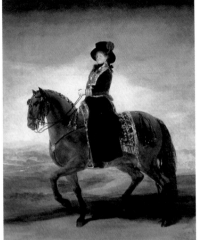

■ Goya, *Portrait of Charles IV on Horseback*, 1799, Museo del Prado, Madrid. Despite the familiar subject matter and stance, Goya's technical ability transforms his portraits of the royal couple into veritable masterpieces.

Portraits on horseback

From the fourteenth century onwards, portraits on horseback were very much in fashion, both in painting and in sculpture. Titian's portrait of Charles V (1548), in which he used a background alive with light and colour and created a character of imposing sculptural quality, was to have a profound influence on the modern style. Titian was not the first, however, to use this technique: Donatello's *Colleoni*, for example, was executed in a similar style.

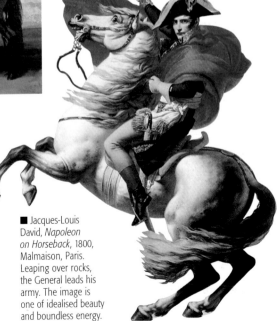

■ Jacques-Louis David, *Napoleon on Horseback*, 1800, Malmaison, Paris. Leaping over rocks, the General leads his army. The image is one of idealised beauty and boundless energy.

59

The Sleep of Reason Produces Monsters

This nightmarish vision is one of Goya's *Caprices* prints, published in January 1799. "The imagination abandoned by reason produces impossible monsters; it is also the mother of the arts and gives birth to their miracles."

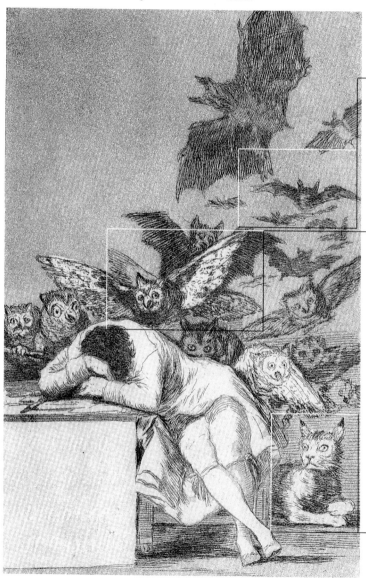

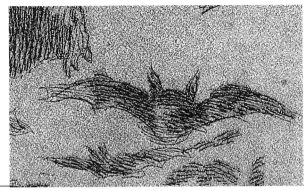

■ Goya's technique is masterly in the way he integrates aquatints with his etchings, a significant advance from Velázquez' technique in which the latter was superimposed on the former. Here the bats, symbols of filth and lust, become ever more menacing as they circle the dreamer's head.

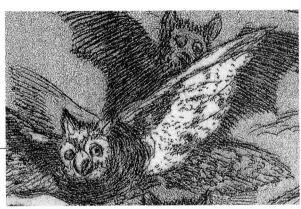

■ The reference to the social and political situation in Spain is evident, despite its apparent subtlety. Indeed Goya's images are sufficiently powerful and evocative to incur considerable criticism. Even the Academy, never fond of engravings, took a stand against them and forced Goya to withdraw them from sale.

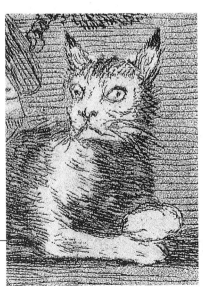

■ The cat, a favoured subject since ancient times, has long been associated with witchcraft.

■ This magnificent preparatory sketch was accompanied by a note stating Goya's intention in his choice of subject. It was "to banish harmful thoughts and perpetuate with this work of *Caprices* the solid testimony of truth."

Goya, painter to the Court, Goya, the satirist

I
s it possible for an artist to have two souls, two distinct styles? In Goya's case the answer is certainly yes. There were his own works, executed for pleasure, which were ironic and often cruel. Then there were the official paintings, all pomp and circumstance, which nevertheles included touches of irony, elegantly woven into Goya's choice of colors or particular lighting effects. The two distinct styles are as revealing about Goya the man as about the times he lived in. In 1800 he painted what is almost certainly his greatest work, the portrait of the family of Charles IV. The assembled members appear in a room within the palace, bedecked in all their regal finery, but stripped of humanity. The artist paints himself at the back of the group, as Velázquez had done in *Las Meninas*. The young Ferdinand, heir to the throne, stands in front of Goya. Not completely sated by this satirical piece, Goya went on to criticize the royal family in his *Portraits* of them out riding, once again paying homage to Velazquez in his choice of composition.

■ *As Far Back as his Grandfather*, plate 39 of the *Caprices*, 1797–98. The government minister Manuel Godoy wanted at all costs to establish his descendancy from the kings of the Goths, for which he had the full approval of Maria Luisa. Goya compared him, somewhat uncharitably, to an ass!

■ Goya, *The Family of Charles IV*, 1800–01, Museo del Prado, Madrid. What pointless arrogance and laughable self-assurance emanate from the royal family. Here reality and appearances vie with each other in evident discord; only the children seem to be free from the fatuousness of the adults.

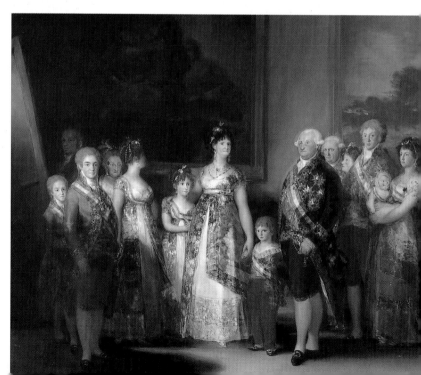

■ Goya, *The Countess of Fernan Nuñez*, 1803, private collection, Madrid. This is another splendid portrait by Goya which again shows the esteem in which he was held by the aristocracy. Light and dark tones merge with luminous intensity.

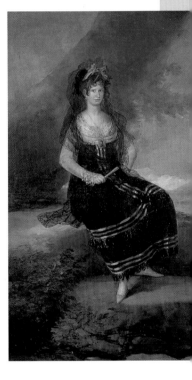

■ Goya, *The Countess of Chincon*, 1800, private collection, Madrid. At the time of this portrait, the Countess had been married to the powerful minister Godoy for three years. Goya's sensitive painting shows her in an advanced state of pregnancy.

The dawning of Romanticism

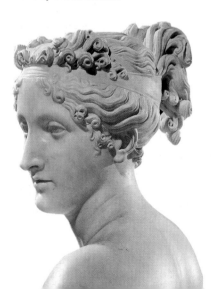

Acontemporary of Goya, the sculptor Antonio Canova was a similarly sensitive and passionate artist. Some of his works, in particular his studies and models, display an expressiveness and sincerity which are startling in their immediacy. Indeed these pieces are so perfectly rendered, so vibrant and so exquisite, that they appear to embody the very essence of Romanticism – beauty as an indefinable yearning. Even the view of Napoleon as leader of the people, commanding officer, and father of the new Europe, encapsulated new Romantic ideals. At the same time religion was undergoing a process of change, as was faith. Christianity, cleansed of its former Baroque dogmatism, re-emerged in a movingly personal form of spirituality. As Chateaubriand wrote in his *Genius of Christianity* (1802), it was now purer, more beautiful, a divine faith which filled and strengthened the heart of the melancholy hero. And within the fields of philosophy, literature, and poetry, there were shared beliefs and ideologies, but there were differences too, both between nations but also within intellectual circles from one group to another. It took another century before the tenets of Romanticism were clarified and more generally accepted, not surprisingly, since a *community* is made up of *individuals*.

■ Anne-Louis Girodet-Trioson, *François-Auguste-René de Chateaubriand*. Chateaubriand (1768–1848) was one of the most important European writers, who greatly influenced Romantic literature.

■ Andrea Appiani, *Napoleon Crossing the Great San Bernardo*, an engraving by Francesco Rosaspina, from the *Napoleonic Records*, 1803–07, Civica Raccolta Bertarelli, Milan. The monochromatic decorations executed for the Palace in Milan were destroyed during the 20th century, but some extraordinary engravings have survived.

■ Antonio Canova, *Pauline Borghese as Venus*, 1808, Galleria Borghese, Rome. This detail shows how the sculptor is both classical (by modelling his subject on Greek and Etruscan examples) and modern, in its sensual beauty. The work is finely balanced between Neoclassicism and Romanticism.

■ Vicente Lopez, *The Family of Charles IV*, 1802, Museo del Prado, Madrid. This painting portrays the royal visit to the University of Valencia. Despite being surrounded by classical allegories, the family is made to look ridiculous.

■ Antoine-Jean Gros, *Bonaparte at Arcole*, 1796, engraving by Giuseppe Longhi, Museo Napoleonico, Rome. Executed in Milan, this portrait is one of the most important documentary records of Napoleon that exists.

■ Andrea Appiani, *Napoleon as First Consul,* 1803, Villa Melzi, Bellagio. Appiani was First Painter to Napoleon in Italy, and very different in style to his French colleagues. He portrays a real man intent on his work rather than a mythical hero.

1793-1803

Naked Maja

Executed in 1800, this is one of the most seductive nudes of all times. It formed part of Minister Manuel Godoy's collection and was later confiscated by the Inquisition; Goya faced charges of "obscene painting" as a result.

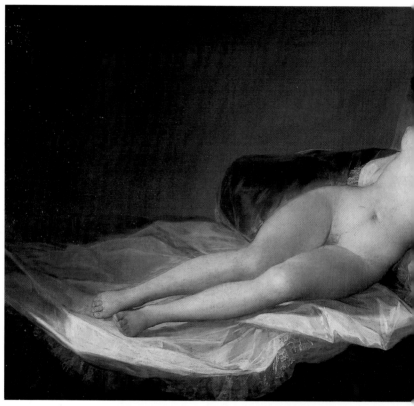

■ Diego Velázquez, the *Rokeby Venus*, c.1648, National Gallery, London. After coming into contact with Venetian painting, Velázquez refined his style, applying touches of overlapping color. This work is thought to be his only nude.

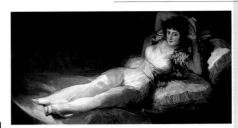

■ Goya, *Clothed Maja*, c.1805, Museo del Prado, Madrid. It seems likely that this painting was executed to cover up the maja's nakedness. It is nevertheless just as enticing as the unclad version.

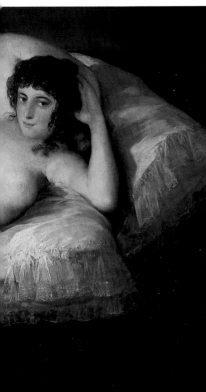

■ Edouard Manet, *Olympia*, 1863, Musée d'Orsay, Paris. The artist was denounced for the overt sexuality of his portrait. However Manet's beautiful woman meets our gaze without shame; the light caresses her pale skin and reflects from the satin sheets on which she reclines.

■ Titian, *Venus of Urbino*, 1538, Galleria degli Uffizi, Florence. Titian painted a number of nudes, often harking back to classical themes. This portrait was commissioned by Guidobaldo, Duke of Urbino.

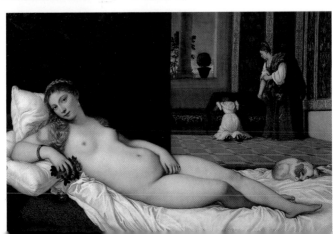

Goya, *Clothed Maja*, c.1805, Museo del Prado, Madrid

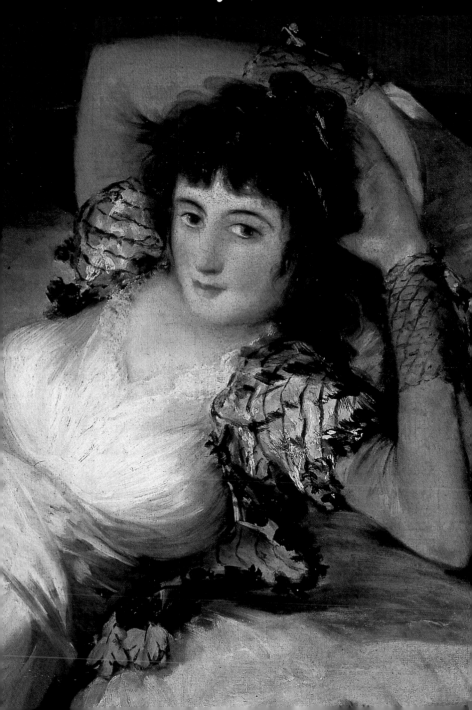

Goya, chronicler
of history

1804-1818

Years of hardship and obscurity

By 1800 Goya had arrived at the height of his fame and official recognition, but his overwhelming desire to challenge convention was to be his downfall. He started painting works which failed to find favour within Court circles. From then until 1808 Goya, who was the official First Painter, received no commissions from the King. Goya was not without work, however, and painted numerous portraits over these years, showing increasing evidence of a more bourgeois style which would come to characterize the nineteenth century. As well as commissioned portraits, he painted many works purely for pleasure. These were often small pieces, painted in series, such as the miniatures executed in tempera on copper for the Goycoechea family which were acquired by his son Javier on his marriage to Gumersinda. Around this time Goya started drawing again, and rekindled an old flame. His meticulously ordered albums give us a unique perspective on the private Goya, a man who suffered for his country and who felt painfully isolated by the deafness which had engulfed him. He vented his anger via these extraordinary images which challenged and denounced the ever-spreading corruption.

■ Goya, *The Duchess of Alba with her Governess*, 1795, private collection, Madrid. Similar to another work featuring his much loved Duchess, this study is handled with extreme vivacity and spontaneity.

■ Goya, *The Marquesa of Santa Croce as Euterpe*, 1805, private collection, Bilbao. This portrait features the 21-year-old daughter of the Duke of Osuna. There is an unresolved quality to the work, visible in the handling of the background vis à vis the girl's figure in the foreground.

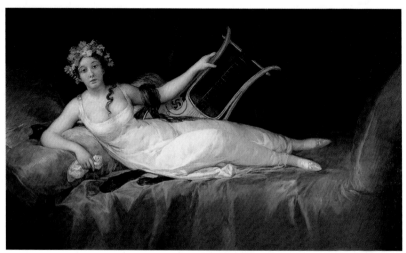

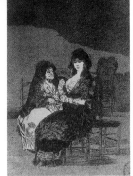

■ Goya, *Fine Advice!*, from the *Caprices*, 1797, Madrid. Fine advice must be that which the madam, or even the mother, gives the young girl – probably how best to capitalize on her assets…. Notice the expert handling of light and shade in this etching.

■ Goya, *Celestine and her Daughter*, 1808–1810, private collection, Palma, Mallorca. Goya is still fascinated by the *maja*, a typically Spanish character. *Majas* are generally good looking and somewhat brazen, dressed in tight bodices and wrapped in alluring *mantillas*.

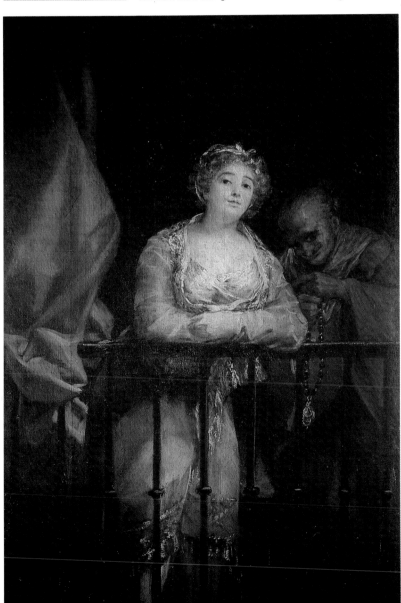

Napoleon and the arts

The years straddling the 17th and 18th centuries saw the emergence of a number of important philosophical and literary works. In 1807 Hegel published his *Phenomenology of Mind*, Fichte wrote *Speeches to the German People*, and Foscolo wrote *Of Sepulchres*. Napoleon was in power and his charismatic personality made itself felt even within the arts. He had become Emperor in 1804 and went about commissioning works which depicted him, in order to leave a lasting impression on museum collections in all the capitals of his Empire. Canova, David, and Appiani were among the famous artists who undertook to depict Napoleon as the leading military captain of his time, and indeed of all time. They immortalized him in his rise from consul to Emperor in styles both realistic and celebratory. The Emperor was greatly impressed by the story of an imaginary ancient Gaelic poet, Ossian, the creation of an Englishman, Macpherson, around 1762. The tale of Ossian had such a deep effect on Napoleon that he wanted to decorate the walls of the Malmaison with scenes from the poem.

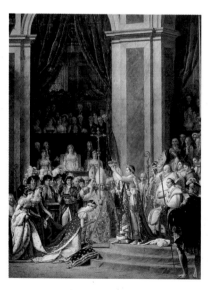

■ Jacques-Louis David, *Consecration of Napoleon*, 1805–07, Musée du Louvre, Paris. In this large work – 6 x 9 metres (20 x 30 feet) – minute attention is paid to every detail.

■ Antonio Canova, *Napoleon*, 1809–12, Galleria d'Arte Moderna, Milan. Canova treats his subject matter as though he were an ancient Roman. The result is an idealized beauty with little bearing on reality.

■ Andrea Appiani,
Parnassus, 1810,
Villa Belgiojoso, now
Comunale, Milan. Here
again we see an artist
returning to the classical
Renaissance style. The
painting was executed
for the ceiling of the
country residence of
the Belgiojoso princes.

■ Giovanni Antonio
Antolini, *The Plan of
the Bonaparte Forum
in Milan*, 1800. This was
an early prototype of
town planning relating
to the area around
the Sforzesco Castle,
complete with public
lawns and a canal.

■ The courtyard of
the Accademia and
the Pinacoteca of Brera
in Milan. Canova's
*Napoleon Depicted as
Mars, the Peacemaker*
stands in the centre.
Napoleon made large
donations to national
art collections.

The Colossus

Goya painted this powerful allegory of war between 1808 and 1810. It depicts the convoy's terrifying encounter with the giant, who suddenly rises up from behind the hill, but turns his back on the screaming masses.

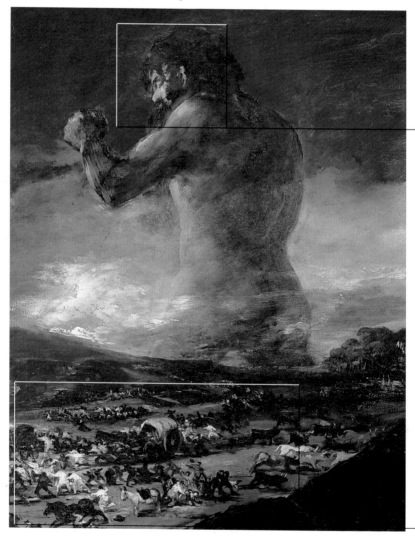

■ His face is bearded and his expression menacing, but the overall effect does not suggest immediate danger. The paint is applied in thick, loose brushstrokes, endowed with an inner luminosity.

■ At the sight of the hideous apparition, the convoy disperses, men and animals alike running for cover. Among the various interpretations of the monster is that it is the defending guardian of the Spanish nation rising up against the Napoleonic threat, and thus a benevolent force.

■ Goya is fascinated by this theme, and returns to it repeatedly. He paints analogous subjects relating to physical atrocities and human suffering with characteristic passion. This particular rendering of the Colossus reveals a monster of powerful build against an unusual, diffused background.

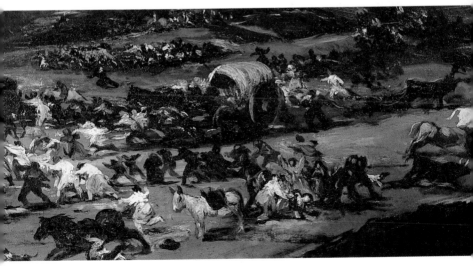

The eye of the artist
and of the patriot

Goya anguished over the situation in Spain, but could not allow his patriotic feelings to override his professionalism. With some reluctance, he continued to accept Court commissions. Napoleon had invaded Spain towards the end of 1807, claiming that he was protecting the country from a British invasion. Then, during the spring of 1808, he attempted to take control of Madrid, and there was mass rioting in the streets. Charles IV abdicated in favour of his son Ferdinand, who only stayed in power for a month. Napoleon replaced him with his own brother, Joseph, declaring this Frenchman King of Spain. This marked the start of the guerrilla war between the people of Spain and the brutal Napoleonic forces. Goya sensed it was time to detach himself from his association with the Spanish Court, and embarked on a series of prints entitled *The Disasters of War*. These manifested Goya's profound sense of outrage at the insanity of all conflict. He was contemptuous of both the ruling powers and the machinations of the Church, neither of which appeared cognisant of the suffering of the people. The final engravings were executed after the end of the war and present allegories of human behaviour at its lowest ebb. During the same period Goya painted some brilliant scenes of popular life, as well as still lifes.

■ Goya, *What Courage!*, from *The Disasters of War*, 1810–20. In Goya's imagination, *majas* were not merely frivolous temptresses, they could also be brave young women, ready to take on the enemy one to one in defence of their city. Notice how the areas of white heighten the plasticity of the forms.

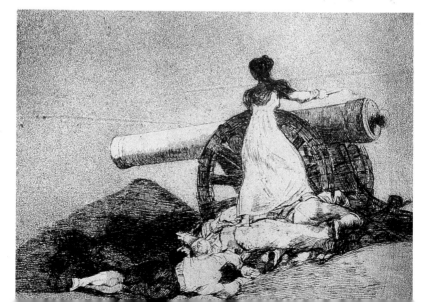

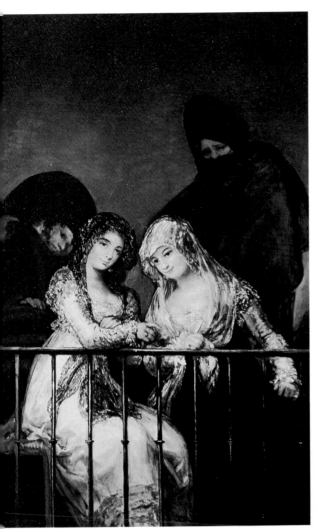

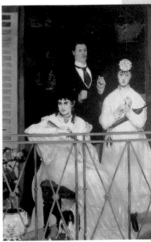

■ Edouard Manet, *The Balcony*, 1868–69, Musée d'Orsay, Paris. This beautiful work is as luminous as the Spanish original to which Manet is clearly paying homage.

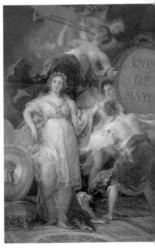

■ Goya, *Majas at the Balcony*, 1805–12, Metropolitan Museum, New York. Shrewd and alluring, these *majas* are among the most beautiful ever rendered by Goya. They appear luminous against the dark background, but even their graceful charm cannot obscure the two sinister figures lurking behind them, symbols, perhaps, of Napoleonic soldiers. The *majas'* style of dress here is typical: high waistline, tight bodice, and pronounced décolletage. Covering their heads and just touching their shoulders are *mantillas* of fine fabric edged with lace.

■ Goya, *Allegory of the City of Madrid*, 1810, Ayuntamiento, Madrid. Commissioned by the Madrid City Council during the reign of the usurper king, Joseph I, the painting is in a Classical-Baroque style to match the pretensions of the regime.

Changing trends – people and nations

■ Jean-Dominique Ingres, *The Valpinçon Bather*, 1808, Musée du Louvre, Paris. Clarity and formal perfection are at the heart of this masterpiece, where light contributes to create a soft, almost unreal body.

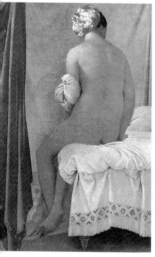

The beginning of the nineteenth century coincided with the start of Romanticism in Europe. As early as 1798 Coleridge and Wordsworth had published *Lyrical Ballads*, the manifesto of English Romanticism. In 1802 Chateaubriand published *The Genius of Christianity* and Foscolo wrote *The Final Letters of Jacopo Ortis*. It is difficult to define Romanticism. The movement was based on a number of precepts: man's innate spirituality, his capacity to relate to nature, since he was a part of it, and to learn from the past while at the same time being very much grounded in the present. In addition, it was concerned with marrying thought and feeling. Soon Romanticism had spread throughout Europe. The French Revolution opened the door to the possibility of abolishing the notion of absolute rule. A sense of national identity was growing in the hearts of the people. In 1961 the historian Federico Chabod wrote "To talk about national identity means to talk about historical independence. One arrives at the principle of nationality as one affirms the principle of individuality, which is to say the importance of the individual as against the generalising tendencies. [...] The concept of a nation for modern man is, above all, a spiritual one; the nation is first and foremost concerned with a feeling, a sense of belonging, and only after that is it a political entity"

■ Caspar David Friedrich, *Abbey under Oak Trees*, 1809, Charlottenburg, Berlin. German Romanticism was particularly concerned with a return to a pure, and highly idealized Christianity.

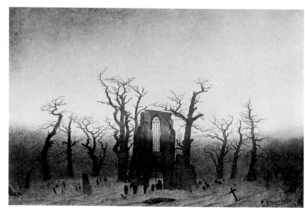

■ Diego Rivera, *The Attempted Insurrection of Miguel Hidalgo*, mural, Mexico City. In the most important region of the Spanish Empire the situation was explosive: heading a group of insurgents, the revolutionary priest Hidalgo cried out for independence, waving an image of the Virgin Mary while marching at the front of an army of paupers.

■ François Gérard, *Maria Luisa and her Son*. The woman wears a splendid, high-waisted dress with train, and a small garland of roses in her hair. A set of matching jewelry completes the effect.

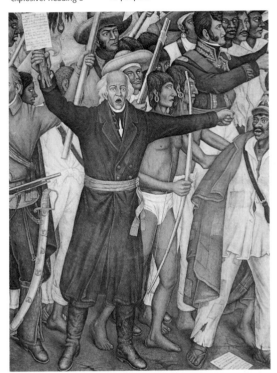

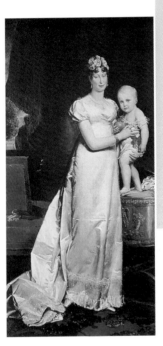

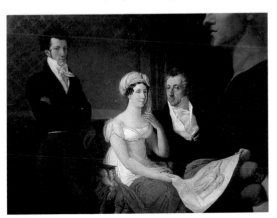

■ Francesco Hayez, *Portrait of the Cicognara Family with a Huge Bust of Antonio Canova*, 1816–17, private collection. The young Hayez follows in the footsteps of the great Venetian sculptor and visits cultured collectors who support his approach to Classical painting.

The Disasters of War

In plate 39, Goya's vision of war is at its most shocking. Entitled *A Brilliant Endeavour! With Corpses!* it forms part of a series of 22 images from *The Disasters of War* which Goya worked on from 1810 to 1820.

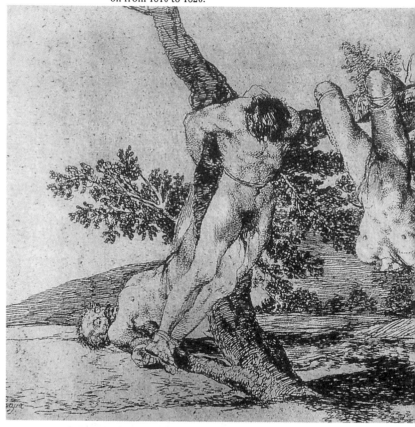

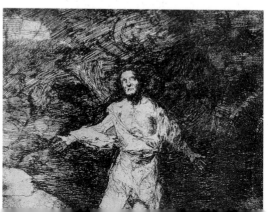

■ *Sad Premonitions of What is About to Happen*, plate 1 of *The Disasters of War*. The man kneeling before his fate with outstretched arms casts a worried glance up at the heavens, where dark clouds gather menacingly above him.

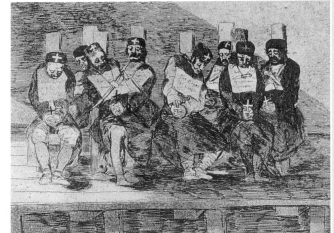

■ *We Can't Know the Reason Why*, plate 35 of *The Disasters of War*. The garotte was one of the most infamous instruments of torture in Europe, and the most commonly used in Spain. The victims were left exposed to public scrutiny as a warning to others. The people were terrified, but they continued their struggles against the regime.

■ *The Carnivorous Vulture*, plate 76 of *The Disasters of War*. The winged monster is attacked by a brave labourer, who brandishes a pitchfork at him while others flee in terror. The grotesque bird might represent the imperial eagle while being an allegory for disastrous government. Perhaps the cleric, visible between the beast's claws, is also used symbolically.

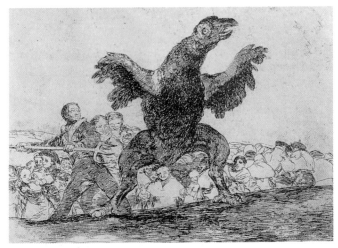

Bitter tastes for Goya in the new Spain

■ Goya, The Second of May, 1808, The Charge of the Mamelukes, Museo del Prado, Madrid. The people attack the Mamelukes, who have been recruited by Marat. The setting is possibly the Puerta del Sol.

Between 1812 and 1813 the English helped to free Spain of the Napoleonic armies. Ferdinand VII was restored to the throne the following year, but proved to be a dangerous tyrant. He even reestablished the Inquisition Tribunal, and the situation of the supporters of liberalism became more and more precarious. Goya disliked him intensely, but was still officially First Painter to the King, and as such was commissioned to paint a number of portraits of him. At the same time he he also painted the Duke of Wellington and Palofax, the Duke of Saragossa, two heroes involved in the defeat of the French army. Goya was in "considerable financial distress" during this period, despite the fact that his wife had left him a small legacy. An inventory was made of his belongings in order to establish exactly what he and his son were due to inherit. To Goya were left the furniture, the silver, the linen, as well as some money; to Javier were left all the paintings and engravings and, in addition, the entire library. This rather unusual division suggests that the relationship between father and son was not what it might have been.

■ Goya, Portrait of Ferdinand VII with his Royal Insignia, 1814, Museo del Prado, Madrid. The "beloved" king of Spanish renewal soon reveals himself to be a reactionary tyrant.

■ Vicente López, Portrait of Ferdinand VII, 1808–11, Museo Municipale, Játiva. The contrast between this portrait and Goya's is enormous: Lopez becomes lost in detail.

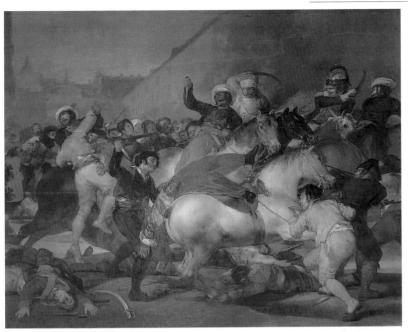

■ Goya, *Mariano Goya*, 1813–15, private collection, Madrid. Goya dedicates one of his most beautiful portraits to his cherished grandson.

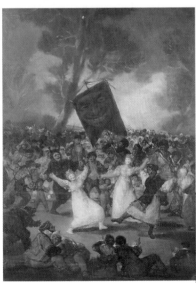

■ Goya, *The Burial of the Sardine*, 1812–14, Academia de San Fernando, Madrid. It is Ash-Wednesday, during the carnival festivities.

MASTERPIECES

The Third of May, 1808: Execution of the Defenders of Madrid

This work, painted in 1814, is in Madrid's Prado Museum.

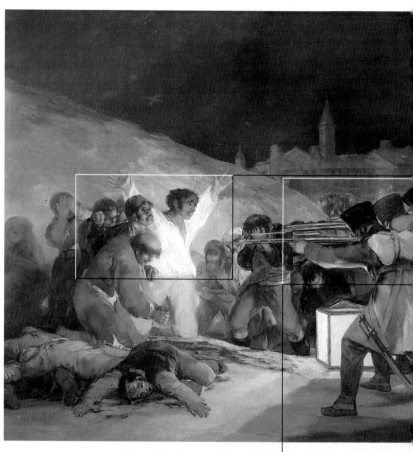

■ The Napoleonic artillery takes aim at the insurgents in the bleak region still known as Moncloa. The work should be viewed in conjunction with *The Second of May, 1808: The Charge of the Mamelukes.*

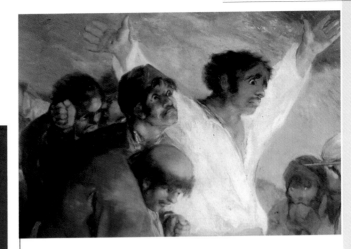

■ At the left of the canvas, the defending hero raises his arms as though prepared to die. The light comes to a focus on his shirt, its luminous whiteness a symbol of purity and innocence. The figure appears as a human torch, crucified in space.

■ Anonymous, *The Assassination of Five Monks from Valencia*, engraving on wood, National Library, Madrid. This print may have inspired Goya. It was one of many which were circulating at the time in the Roman Catholic Spain, where Napoleon was viewed as the Antichrist.

■ *Everything is Topsy-Turvy*, plate 42 of *The Disasters of War*. The Church adapts to the situation. The monks, each man for himself, try to save themselves. The fat one on the left appears less than pleased.

1804-1818

The world of the bullfight

The year 1815 turned out to be a bad one for Goya. Vicente López, a portraitist with a somewhat superficial style, had grown popular with the Court, and Goya was out of favour. It was then that he executed the magnificent self-portrait in which he revealed both his disillusionment and his exhaustion. Two events, however, served to raise his spirits: he received payment from the King for having refused to work for the French, and he made the friendship of a young woman, Leocondia Zorilla. With renewed energy, Goya threw himself into a series of engravings on *The Art of Bullfightin,*. The series is said to consist of thirty-three large works, although there were almost certainly more. The bullfight was a subject close to the artist's heart, both because it reminded him of his youth and also because of his pride in his Spanish heritage. Within the series, Goya charted the story of bullfighting. Arguments raged as to who had actually "invented" the bullfight, and whether its success was due entirely to the panache of the matadors and toreadors. Goya looked at them all, from El Cid, the most famous of the medieval bullfighters, to Pepe Illo, and the artist's indubitable favourite, Pedro Romero.

■ *The Fall from Horseback of a Picador under a Bull*, plate 28 of The *Art of Bullfighting*. Among the various types of bullfight, this Goya-esque one foresaw the wearing of outfits in the style he designed.

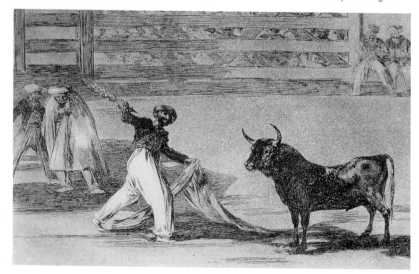

■ Antonio Canaletto and Giambattista Cimaroli, *Bullfighting*, 1760, private collection. Bullfights were not uncommon in Venice; bulls were restrained by means of ropes and dogs who would bite their ears. Three such spectacles were organized in the Piazza San Marco between 1740 and 1782 in honour of important visitors.

■ Goya, *Rita Molinos*, 1815, private collection, Spain. This striking actress inspired in Goya a fascination with feminine beauty. Notice her contemplative pose *vis à vis* that of the famous portrait of Leocadia in 1821 (page 101).

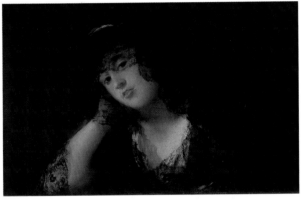

■ *Origin of the Harpoons*, plate 7 of *The Art of Bullfighting*, etching and aquatint, partially burnished and dry tip. The *banderillas* have a harpoon at the tip.

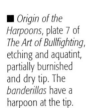

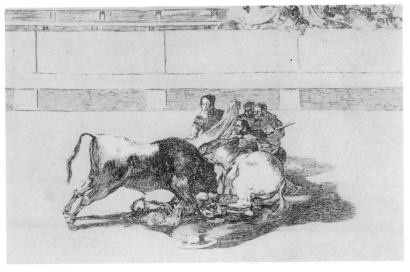

The end of an era

■ Antonio Canova, *George Washington*. Washington, who died in 1799, was one of the most important political figures of the period. A staunch supporter of the autonomy of the Colonies from Europe, he was to be unanimously elected president after the First Congress of the United States on March 14, 1789.

The troubled Napoleonic era was reaching its concusion. Napoleon's plan to conquer the whole of Europe came to a halt on the banks of the Beresina: it was the end of the Emperor. The Congress of Vienna decreed the restoration of a political and territorial status quo, which completely reversed the effects of the centralization operated by Napoleon. Power was restored to the conservatives. The Prince of Metternich was the soul of the Restoration as he controlled the German Federation and part of Italy. The alliance between Austria, Prussia, and Russia represented an insurmountable barrier to any attempt at insurrection. Spain, like France, witnessed the return of the monarchy, as well as revolts in its outlying territories. While in Great Britain the Tories came to power, Italy went through years of uncertainty. Secret revolutionary groups such as the "Carbonari" started to form in some cities. The reevaluation of the ideas of the French Revolution, and of the intellectual movements which had ushered it in, led to the birth of Liberalism. The debate was spurred on in a number of places by a range of people, among them the writers Madame de Staël and her great friend Benjamin Constant.

■ Anne-Louise-Germaine de Staël, French intellectual and writer, published *De l'Allemagne* in 1819. It was considered the first book of the new Europe against neoclassicism and the academic establishment.

■ Gioacchino Rossini (1792–1868) was one of the most acclaimed composers of the time. His *Barber of Seville*, however, first performed in Rome on February 20, 1816, was booed off the stage by Rossini's adversaries, supporters of Giovanni Paisiello, who had set the same opera to music.

■ The Prince of Metternich, a very able Austrian diplomat, was the main agent in the political demise of Napoleon.

■ Caspar David Friedrich, *Dolmen in the Snow*, 1801, private collection. The romantic hero sleeps for eternity in the bosom of Nature, that played a hand in his death by turning to winter. Alone and away from mankind, his only cross is a cold stone.

■ At Waterloo in June 1815, the so-called "Lion from Corsica" fought his last battle. He managed to escape because of enemy blunders and abdicated the following month.

Mass for a New Mother

This work, the first of four versions, was painted between 1813 and 1818 and is in a private collection in Madrid. It is often viewed in relation to the *Procession of Flagellants* (1813–18) in the Museo Nacional of Buenos Aires.

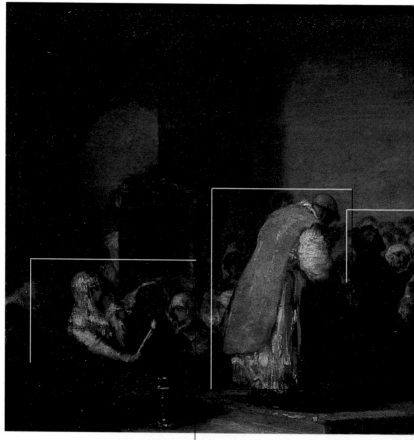

■ The young woman forms one of the focal points of the composition as she kneels and holds out a devotional candle. Her veil and her blouse stand out against the dark surroundings.

■ We can virtually feel the agitation of the faithful: kneeling around the altar, they emerge from the darkness of the church, a host of anonymous faces contorted by their emotions. The monk stands out among them, framed by the blackness of his cloak.

■ The priest's cloak is a triumph of warm and brilliant tones, applied thickly in an almost granular manner. The use of a bowing figure reappears in *The Last Communion of St Joseph of Calasanz*.

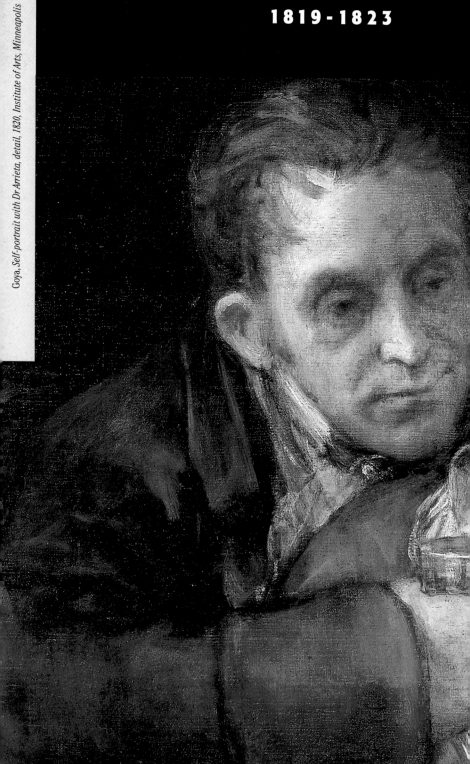

New dramas on
the horizon

The "Quinta del Sordo"

With his health steadily deteriorating, Goya entered the final phase of his life. In 1819, after a period of working in Andalusia, he bought a house in the countryside around San Isidore. It was known as "Quinta del Sordo", the house of the deaf man, due to a former occupant, and Goya retreated there, far from the attentions of the outside world, with the loving companionship of Leocadia. Thanks to the care and skill of his friend Dr Arrieta, Goya appeared to make a partial recovery. His brief period of good health corresponded to a period of "good health" in Spain's political life which, from 1820, boasted a liberal constitution. We know that Goya was present at the Royal Academy of San Fernando on April 8, 1820 in order to swear his allegiance to that longed for constitution. Goya expended enormous energy on sketches for decorating the two rooms of his new house, which were dubbed "black paintings" due to their subject matter. He painted them quickly, with oils applied directly on to plaster. These works are among the hardest to interpret and to link together. At the same time, Goya accepted a commission for his final religious painting, *The Last Communion of St Joseph of Calasanz*, which he undertook for the monastic order with whom he had first studied art, all those years ago. He completed the painting in three months. As soon as he had finished it he discovered a new, all-consuming method of working – lithography.

■ Goya gave his house to his grandson Mariano on September 17, 1823. By that time he had completed all the so-called "black paintings".

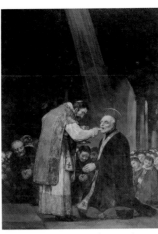

■ Goya, *The Last Communion of St Joseph of Calasanz*, 1819, San Antonio Abad, Madrid. This painting is rightly heralded as Goya's greatest religious work. It displays a masterful handling of shades of gold, and is full of emotional intensity.

■ Goya, *Saturn*, 1821–23, Museo del Prado, Madrid. Goya's terrifying portrayal of Saturn is already Expressionist in style.

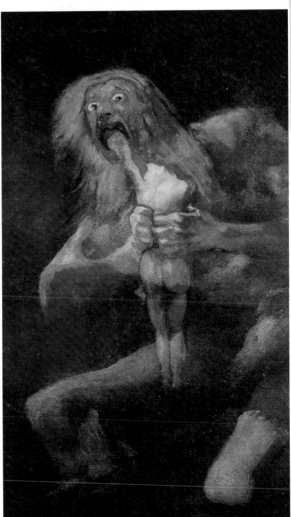

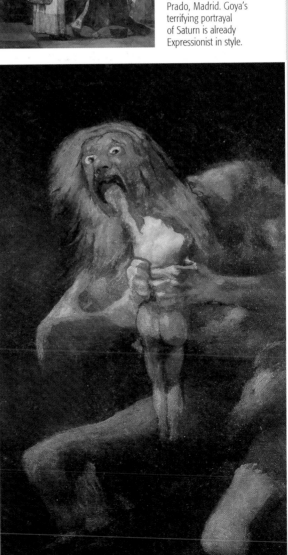

■ Peter Paul Rubens, *Saturn Devouring his Son*, 1636, Museo del Prado, Madrid. Rubens loved mythological subjects. His vigorous style and use of light adds to the sense of drama.

1819-1823

Science and technology in the spotlight

■ The *Draisienne*, as seen in a French print of the early 19th century. It was invented in 1818 by Karl F. Drais and aroused keen interest.

At this time, science and technology were making huge advances. Modern science had started at the end of the seventeenth century, and the following century was characterized by a succession of important discoveries and a proliferation of scientific publications. Inevitably, the theoretical aspects were bound up with the practical ones. As Goethe wrote in his *Theory of Colour* (1810), "It is indeed a strange claim, often advanced but seldom respected even by its very supporters, that scientists should relate their experiences outside any theoretical context." In his work, the *Course of Positive Philosophy*, Auguste Comte commented: "If any positive theory must of necessity be founded on observation, it is just as evident that, to dedicate ourselves to the practise of observation, our soul needs to possess some theoretical thought." The following are just a few of the results of research from the early nineteenth century. In France, in 1801, the Committee for Weights and Measures approved the decimal metric system. In 1800 Volta built the first electric battery and in 1802 he explained the phenomena of light interference and of light waves. In 1820 Oersted proved the relationship between circular electrical current and magnetism. In 1822 Fourier published his *Analytical Theory of Heat*, while in 1824 Carnot wrote *Reflections on the Motive Power of Fire*. The laws of electrical current were described by Ohm in 1826.

■ The Prado Museum in Madrid. The building was constructed half a century earlier, but the actual Museum opened to the public on November 17, 1819. It contained three hundred and eleven works, which, however, could only be viewed on Wednesdays.

■ Théodore Géricault, *The Raft of the "Medusa"*, 1818–19, Musée du Louvre, Paris. The canvas was inspired by an event of June 1816 – the sinking of the ship *Medusa*.

■ Sketch for *The Raft of the "Medusa"*, 1818, Musée du Louvre, Paris. Painted in oils on canvas, this sketch allows us to appreciate the genesis of the creative process.

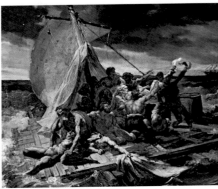

■ Sketch for *The Raft of the "Medusa"*, 1818, Musée du Louvre, Paris. Because of his meticulous method of working, which involved making countless studies, Géricault completed only a small number of works during his lifetime.

A devastating turn of events

Géricault's main concern was to capture an "absolute truth" in his painting. To that end, he chose to reproduce what he saw as the most dramatic moment – the hope of rescue by the shipwrecked men. Tragically, the ship was too distant to notice them. When the painting was first exhibited at the Salon of 1819, it was criticized for lacking a central focal point.

1819-1823

Self-portrait with Dr Arrieta

This painting (1820), housed in the Minneapolis
Institute of Arts, is among the most intimate and
moving of all the artist's work. The expressions of
the two central figures command our attention.

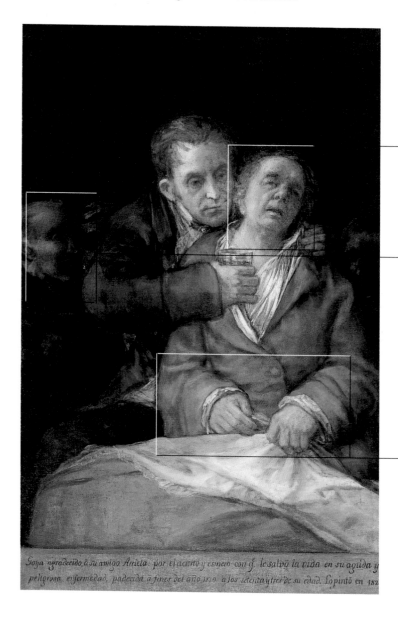

*Goya agradecido, á su amigo Arrieta: por el acierto y esmero con q.ͤ le salvó la vida en su aguda y
peligrosa enfermedad, padecida á fines del año 1819. á los setenta y tres de su edad. Lo pintó en 182*

■ In attempting to render his own features, Goya uses such transparent applications of color that you can see the bare canvas below. The flesh on his face and neck is so lifelike as to be disturbing.

■ At first glance it is easy to miss the sinister figures on the left-hand side. They take on the role of harbingers of death – hideous apparitions created by the imagination in moments of panic.

■ Goya's determination to stave off death is visible in his hands, which appear to be literally gripping the sheets for dear life. The whiteness of the linen echoes the paler tones in his hands and in his night-shirt. The solicitous features of his medical friend are rendered with equal attention to detail, and form a powerful counterbalance to Goya's sickly pallor.

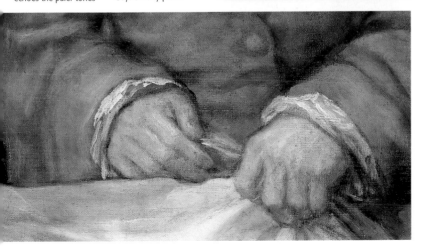

The "black paintings"

The "black paintings" are among the most mysterious of Goya's late period. They consist of fourteen works executed in oil-on-plaster for his house, La Quinta. This oil-based *al secco* technique was fairly common at the time as the slow-drying properties of the oils allowed for alterations and greater spontaneity. On the ground floor Goya painted *La Leocadia, Two Old Men, The Great He-Goat, The Pilgrimage of San Isidore, Saturn,* and *Judith and Holophernes.* On the first floor, *The Fates* and *Asmodea, Duel with Cudgels, A Dog*; and lastly, *The Procession of Sant'Uffizio, Men Reading,* and *Two Old People Eating.* Once again these paintings reflect the artist's macabre state of mind. Scientific investigations of the paintings show that Goya had originally set out to make joyous images on the walls, full of lively dance movements. The return of the monarchy in Spain, demanded by the Congress of Vienna, must have signalled Goya's abrupt change of heart and iconography; hence the malevolent gods, the powerful allegories, and the foolish beliefs.

■ Eugène Delacroix, *Faust in Flight,* lithograph for Goethe's *Faust,* 1828. This work by Delacroix is clearly inspired by Goya.

■ Goya, *Asmodea,* 1820–21, Museo del Prado, Madrid. The witch with the red cloak, named after the biblical demon whom Tobias vanquished, has a man, terrified and powerless, in her clasp.

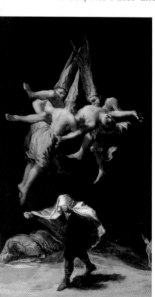

■ Goya, *Flying Witches,* 1797–98, Ministerio de la Gobernación, Madrid. Goya had long been fascinated by witchcraft, as evidenced by this much earlier painting.

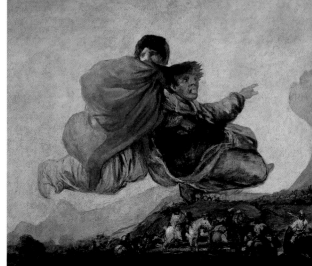

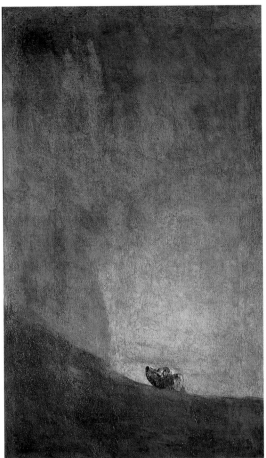

■ Goya, *A Dog*, 1820–21, Museo del Prado, Madrid. As the pictorial surface gradually dematerializes within the sparse framework, it is unclear whether the dog is battling against a powerful current or sinking in quicksand. He stands as a metaphor for man's struggles against the quagmire of human experience.

■ Goya, La *Leocadia*, detail, 1821–23, Museo del Prado, Madrid. This painting is also known as *Una Manola*, which means an elegant woman of Madrid.

BACKGROUND

The stage opens on a new century

In 1819 Sir Walter Scott published *Ivanhoe*, a milestone in European literature which ushered in the historical novel. The author went to the roots of his country's history, in his case the Middle Ages, and prefaced every chapter with a short classical quotation. By and large he rescued the status of this literary device, which was not much appreciated in the eighteenth century. After Lord Byron, Sir Walter Scott was the most influential British writer in Europe. During the course of 1820 there were numerous uprisings in Spain, Italy, and Portugal against the regimes imposed by the Restoration. The governments came down heavily against them, but by then liberalism and democracy were on their way. One day, a chance discovery by a local peasant was to have a profound effect. He stumbled on the ancient statue of the *Venus de Milo*, giving to the art world one of the most natural and sensuous female figures ever created.

■ *The Cradle of the Duke of Bordeaux,* 1820, Musée des Arts Décoratifs, Paris. The lavish decoration is a pure example of the Neoclassical style.

■ Francesco Hayez, *Then I Will Obey You*, series of illustrations for Sir Walter Scott's *Ivanhoe*. One of 22 lithographs with crayons printed in 1828.

■ Francesco Hayez, *Rowena*, series of illustrations for *Ivanhoe*. Portrayed as a classical and mellow figure, the heroine of the novel represents a woman belonging to times past.

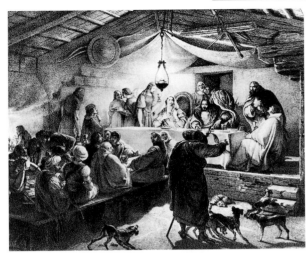

■ Mahogany flower stand with ormolu decoration, fish bowl, and bird cage, Musei e Gallerie di Capodimonte, Naples. A bizarre mix of Neoclassicism and naturalism.

■ *Venus de Milo*, masterpiece of Hellenism in Greece. Sculpted out of marble from the island of Paro, this was discovered in 1820 on the island of Milo in the Aegean.

Asmodea

Painted in 1820–21, *Asmodea* can be seen in Madrid's Prado Museum. Its name may have associations with Aesma Daeva, the angry geni of Persian folklore. Here the diabolical figure flies with its human burden towards the mountain.

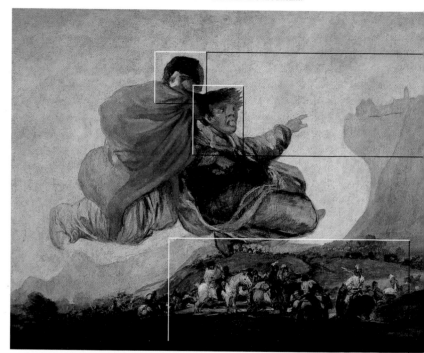

■ The face vanishes beneath the physical features as Goya uses brushstrokes stripped of any recognizable meaning. The face is handled as one solid mass.

■ Some Spanish experts view this figure as a second witch; both are thus bound for a sabbath ritual on the distant cliff-top.

■ The theme of two soldiers is repeated, and even appears in a sketch called *Fantastic Vision*. In this detail as in the sketch they are shooting, but it is not clear who the intended victims are.

■ To fill a space which is in danger of "falling", Goya locates a vast group of figures on foot and on horseback, possibly all heading towards the same place. He has used a cliff as a compositional device in an earlier painting, *The City on the Rock* of around 1816.

1819-1823

Anguish, madness, and hallucinations

There is little doubt that the Black Paintings reflect Goya's state of mind at the time. Just as the first eruption of his illness propelled him towards the *Caprices* and towards religious subjects, so the reemergence of the illness pushed him further into pessimism and misanthropy. More than ever before, Goya saw his existence as plagued by uncertainties, both professional and political. The same negative view of life permeated his etchings called *The Follies*, which Goya started in 1816 and finished in 1823, although they were not published until after his death. Sometimes known as *The Proverbs*, they form his final, most brilliant series of etchings. None of them are dated, and yet Goya must have planned and executed at least twenty-five of them rather than the twenty-two that are known. These works are similar to the *Caprices* in theme. In them we discover man as weak, given to the most insane drives and desires, foolish, impractical, and superficial. The Church is also in the firing line as Goya's views toward it grow ever more critical.

■ *Simpleton's Folly*, plate 4 of *The Follies*. With what an inane grin this castanet-playing simpleton advances towards the priest, hidden from view by a hooded figure. He represents the foolishness of primitive beliefs and fears, with the Church as the antithesis of enlightened thought.

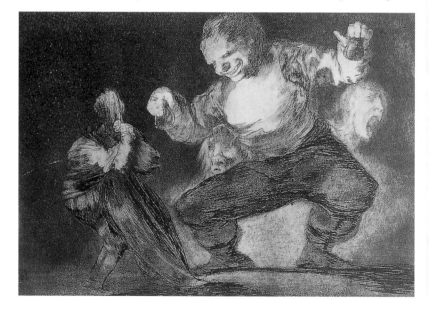

■ Goya, *Self-portrait*, 1815, Academia de San Fernando, Madrid. This is one of the most powerful and moving portraits that any artist has bequeathed to his public. Goya digs deep inside his soul to find some inner truth. In his eyes we glimpse the burden and anguish of a time of great crisis for him.

■ Goya, *Two Old Men*, 1821–23, Museo del Prado, Madrid. Also known as *Two Priests*, critical opinion is divided over this work, which forms part of his series of Black Paintings.

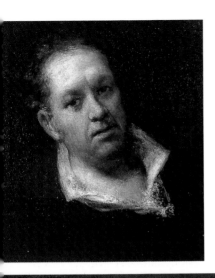

■ Goya, *Tio Paquete*, 1820–23, Thyssen Collection, Madrid. On the reverse of the canvas is written "el celebre fijo", the famous blind beggar and singer.

The deaths of great men

■ Glass chalice (c.1825) with engraved stand and border. The decoration commemorates the opening of the Sunderland Bridge (1796).

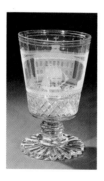

On May 5, 1821, Napoleon died on the island of St Helena, and on October 13, 1822, the sculptor Antonio Canova died in Venice; two great men end their life on earth within a few months of each other. Their passing away brought to an end an extraordinary period in the life and culture of Europe, when there were such great changes that we still marvel at them to this day. The Italian writer Alessandro Manzoni dedicated a poem entitled *The Fifth of May* to Napoleon, imbued with awe at Bonaparte's achievements. Canova dedicated his splendid Temple at Possagno to the Christian concept of death, and to himself too. The Temple resembles a modern pantheon, embodying Canova's belief of art as absolute and eternal beauty. These two men, however, were not the only great figures to die. On July 8, 1822, Percy Bysshe Shelley, one of the greatest of all English poets, drowned off the coast of La Spezia. In 1824, King Louis XVIII died in France and the Emperor Alexander I died in Russia. The composer Carl Maria von Weber, another important figure, died in London on June 4, 1926. And finally, soon after Napoleon, one of his foremost opponents died, Pope Pius VII, who had, however, mainted a moderate policy throughout his papacy.

■ The Temple of Possagno in the Veneto region (1819–30) is the burial place of Antonio Canova; its classical elegance rises above an imposing flight of steps.

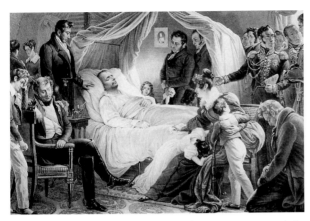

■ Napoleon dies at St Helena surrounded by his family and close friends. The last hour of the "man of destiny" reminds the poet Manzoni of the greatness of the most able of leaders, while all of Italy falls silent at the announcement of the Emperor's death.

■ Francesco Hayez, *Pietro Rossi (…) deprived of all his possessions by the Signori della Scala, (…) while sent to Pontemoli Castle, (…). to assume the command of the Venetian army, is urged (…) not to undertake this enterprise*, 1821, private collection, Milan.

■ John Constable, *Studies of Clouds,* 1822, private collection, London. A naturalistic observation of a changing sky.

The Pilgrimage of Saint Isidore

Painted between 1820 and 1821 for Goya's
house La Quinta, *The Pilgrimage of Saint Isidore*
is now in Madrid's Prado Museum. It presents a
typically bleak view of humanity made up of
Goya's panoply of grotesque characters.

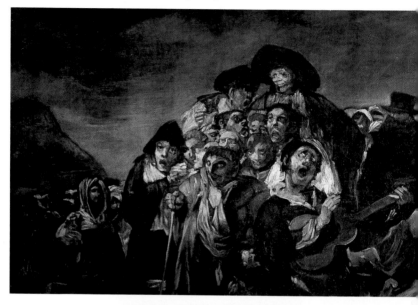

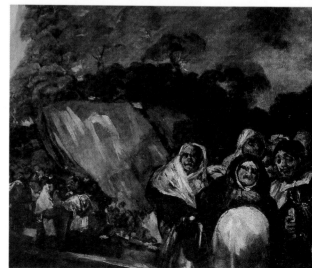

■ Goya, *The Pilgrimage
to the Fountain of Saint
Isidore*, 1820–21,
Madrid, Prado Museum.
This detail shows a part
of the company of
faithful who are making
their way towards the
hermitage of St Isidore
where, according to
legend, there was a
magic fountain. Saint
Isidore was Madrid's
most popular saint.
It is not impossible
that the throng
represent members
of the Inquisition,
who Goya despised.

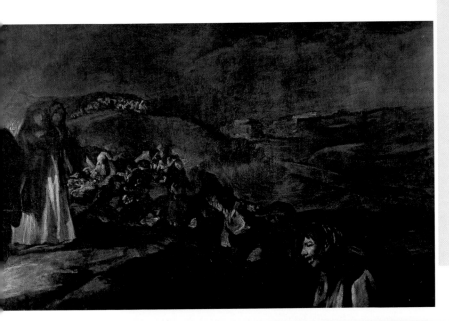

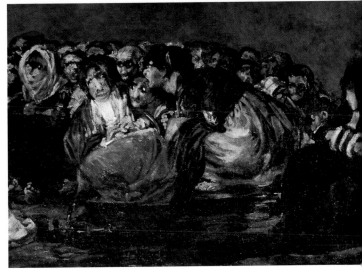

■ Goya, *Sabbath*,
1820–21, Museo del
Prado, Madrid. In
this detail we see the
sorcerers gathered
together to perform their
secret rite. Goya tears
this group out of the
background by means
of a few touches of
color. With simple
brushstrokes he renders
expressions, postures,
and clothing. The woman
seated at the extreme
right may be his
cherished Leocadia.

A prolific genius
till the end

Events happen in quick succession

After 1823, things happened fast both for Spain and for Goya. In August of that year Ferdinand VII, imprisoned by the Liberals, was freed and reestablished the much-hated status quo. Goya decided to sign La Quinta over to his grandson and fled Madrid in order to escape the reactionary backlash. Then in 1824 he requested permission to go to Plombières for a thermal cure. This having been granted, he went instead to Paris where Leocadia, also unpopular with the ruling powers, had been in hiding. Early in September 1824 Goya landed in Bordeaux and was joined by Leocadia. By this time his health had deteriorated: his eyesight had weakened and he was suffering from a mild paralysis. Nevertheless he continued to work, painting portraits, executing the *Follies* lithographs, and making miniatures such as the famous series painted on ivory. Goya's unique approach to painting won him the admiration of countless artists and intellectuals. He used nature as his starting point, but treated it in a characteristically non-academic way. "I had three masters: Rembrandt, Velázquez, and Nature" he once commented, adding, "Where are the lines in nature? All I see are dark and light bodies, planes which advance and ones which recede, projections and cavities…"

■ Goya, *Self-portrait,* 1824, Museo del Prado, Madrid. How different the artist appears now from his early view of himself at work at his easel.

■ *Merry Folly*, plate 12 of the *Follies*. This work echoes the carnival theme of his earlier *Burial of the Sardine*.

■ Goya, *Scenes from a Bullfight*, 1824–25, Museo del Prado, Madrid. The small scale of the canvas, just 32 x 44 cm (12½ x 17½ in), serves to accentuate the brightness and spontaneity of the colors.

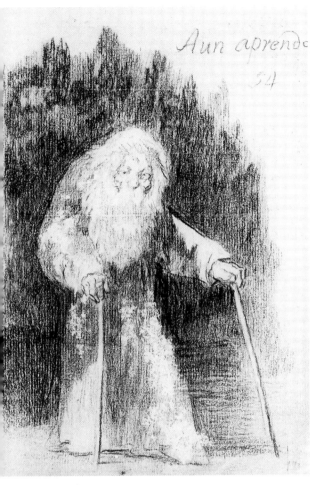

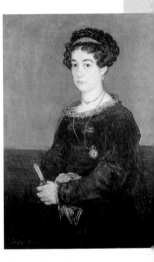

■ Goya, *I am Still Learning*, 1824–28, Museo del Prado, Madrid. The old man can no longer walk without the aid of sticks, but he is "still learning". This image seems to epitomize the artist: neither age nor disease could stand in his way.

■ Goya, *Maria Martinez de Puga*, 1824, Frick Collection, New York. This is one of Goya's last paintings. It is no less successful for being painted during the turbulent period just prior to his exile.

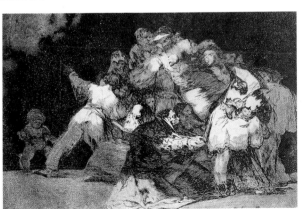

■ *In General Folly*, Plate 9 of the *Follies*. Everyone is in the throes of madness, except an old man lurking in the background. Perhaps that lone figure is Goya, retreating from the world.

1824-1828

The arts change with the times

■ Robert Owen, a labourer who became the owner of textile factories in Great Britain, was one of the first to reform working practices. One of his ideas was the first "workers' communities".

The pressure exerted by the supporters of liberalism and democracy increased in response to the repression from the reactionary factions. The people joined forces, even in Greece, where they started a war against Turkey after almost four hundred years of living side by side. In the art world, the Romantic movement became ever more firmly established and was even seen, as A. Hauser wrote, as a "fight for freedom, fought not only against the Academies, the Church, the courts, the patrons, and the critics, but also against the very principles of tradition, authority, and rule. Decorative objects were still very much in demand, in particular porcelain, jewelry, glass, furniture with marble tops, mirrors with elaborately carved frames. It was the sphere of industry, however, which really promoted development. Headed by Great Britain, where the changes were most readily apparent, the growth of industry spread first to Germany and France, and then gradually to other nations. Chemistry and metallurgy joined to achieve the best quality products for an ever expanding market. The extended system of rail transport meant that these products could now be easily moved from one country to another.

■ Wedgwood Factories, pot-pourri vase with lid, jasper-ware, c. 1851. The pieces produced in the second series of *Etruria* were shown at the Great Exhibition in London.

■ Wedgwood Factories, vase in jasper-blue ware with white relief decoration, 1787. The vase is ornamented with Venus and Cupids reclining on swans, and snake-like handles. The famous British company, named after its owner, soon became one of the most important in Europe.

■ Lord Byron (1788–1824) died at Missolonghi in Greece while fighting as a volunteer in the war between Greece and Turkey. The poet, who had started writing when he was just eighteen years old, embodied the image of the hero: he defied the world armed only with his courage, and gave his life to the ideal of freedom.

■ London's Buckingham Palace, was rebuilt in Corinthian style for the royal family by the architect John Nash in 1825–30. Its name derives from the 18th-century palace on the same site, which was sold to King George III.

■ Park Crescent in London's Regents Park, was built by John Nash in 1812. It is one of the most important urban projects in Ionic style.

7

Bullfights – with two picadors

Executed in 1825, this scene from a bullfight forms part of the Prado Museum collection in Madrid. Notice Goya's exceptional ability in giving a sense of excitement and energy to the action; the spontaneity of his brushstrokes creates an almost filmic sense of movement.

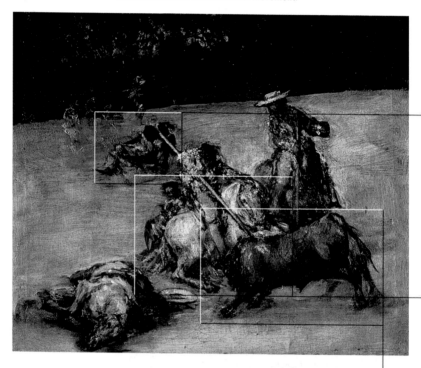

■ The *Art of Bullfighting* series is intended as an *"excursus"*: a visual record of the ancient art of bullfighting together with the various techniques employed by man in combatting his noble adversary. For Goya, it was a celebration of bullfighting in all its glory and a paying of homage to the skill of the matador.

■ Behind the main action another battle is being fought; a second bull falls under the onslaught of the *banderillas*. This background scene is rendered with the barest of colors – the bodies of the bullfighters are created with the merest touches of white; the stricken bull by a patch of black with occasional lighter tones.

■ Just as Goya captures a sense of movement in his Bullfight prints, so he effects the same drama in his paintings through his application of color. The white tones of the horse give form to the darker masses behind it. The whites, blues, and greys, and the earth tones are applied swiftly with confident touches of the brush. The brilliant red blood spilling from the bull stands out against the duller tones behind it.

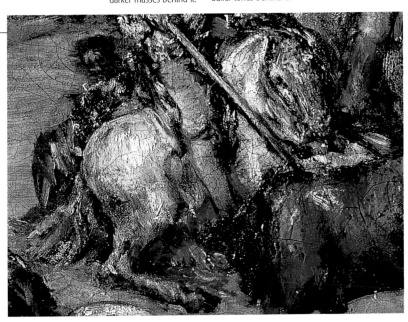

The Bordeaux years

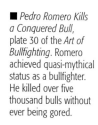

In 1825 Goya wrote to a friend in Paris, telling him about a series of miniatures which he had just completed. He had painted these on ivory, in a similar vein to the *Caprices*, and appeared pleased with the results. The technique he used was to blacken a slab of ivory and then allow drops of water to fall on it to disperse the black and thereby create areas of white. His hunger for new techniques as strong as ever, he completed forty or so miniatures in this way of which no two were the same. In May 1826, his health having improved slightly, he returned to Madrid where Vicente Lopez, First Court Painter since 1815, painted a rare and now famous portrait of him. In 1827 Goya was to make another short trip within his beloved Spain; his energy had not deserted him despite his increasing years. He executed one of his finest paintings, *The Milkmaid of Bordeaux*, that same year, as well as carrying on with his Bullfight series, a subject always close to his heart. With genuine friends around him including, among others, José Pio de Molina and the young artist José Brugada, Goya found the tranquility he needed to keep working. Shortly before he died he painted a final, moving portrait of his grandson Mariano, full of intimacy, tenderness, and psychological intensity.

■ Goya, *José Romero*, 1796, Philadephia Museum of Art. This famous bullfighter was 46 years old at the time of the portrait; the artist's sincere admiration for him radiates from the canvas.

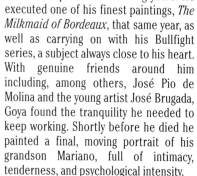

■ *Pedro Romero Kills a Conquered Bull*, plate 30 of the *Art of Bullfighting*. Romero achieved quasi-mythical status as a bullfighter. He killed over five thousand bulls without ever being gored.

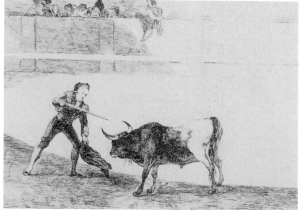

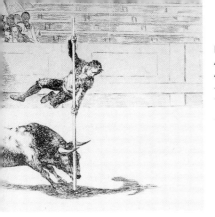

■ *The Agility and Audacity of Juanito Apinani in Madrid's Bull Ring,* plate 20 of the *Art of Bullfighting*. Known as "jump of the lance", this extraordinary move is still much admired.

■ *The Vigorous Rendon while he Spears a Bull with his Lance, an Act which Cost him his Life in Madrid's Bull Ring,* plate 28 of the *Art of Bullfighting*. Goya applies burnished aquatints to his etching plate and adds a touch of burin to the horse's neck.

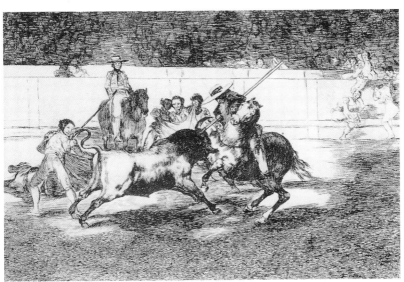

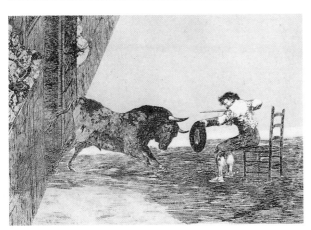

■ *Temerity of Martincho in the Saragossa Ring,* plate 18 of the *Art of Bullfighting*. The bullfighter demonstrates exceptional courage by facing his foe at close range and with his legs chained together. Goya's technical skill was considered charming at the time but not greatly valued; the public preferred prints to be less detailed and to be in color.

121

Challenging times

BACKGROUND

The threads of history during the early nineteenth century were extraordinarily intertwined. The deaths of sovereigns were followed by the emergence of the champions of freedom. Intellectuals, scholars, politicians, the middle classes and the workers, albeit not yet recognized in the social structure, all found common ground against the ruling powers. They fought from their different vantage points, and little by little their concerted actions started to have an effect. Against this background the function of the artist was changing. He was no longer the anonymous executor of works dictated by someone else, someone who was exploited for his technical skill while kept in a subordinate position. The artist was now conscious of being "a man of the times", capable of independent thought and action and, although rooted in the traditions of the past, making a significant contribution to the progress of society. After rediscovering his sense of identity, the artist turned his attention to Nature, and then to the real world. His aim was to progress further and further in order to achieve, as suggested by the art historian Giulio Carlo Argan, "the condition of absolute authenticity of his being"; in other words, to become the ultimate modern man.

■ The front cover of *The Betrothed*, the novel published in Milan in 1827. Its subtitle was *Milanese Story of the 17th Century Discovered and Rewritten by Alessandro Manzoni*.

■ Francisco Hayez, *Imprisonment of the Colonel, Francesco Arese Lucini,* c.1827, private collection, Milan. The style of this portrait, set in a notorious Austrian prison, anticipates Realism.

■ Francisco Hayez, *Portrait of Alessandro Manzoni,* 1840–41, Pinacoteca di Brera, Milan. After experimenting with Neoclassical and Romantic styles, Hayez adopted a far more realistic one, of which this portrait is a fine example.

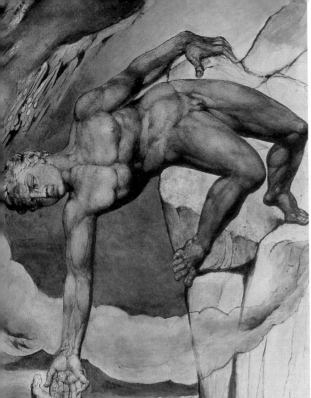

■ William Blake, *Anteus Setting Down Dante and Virgil*, illustration for the *Divine Comedy*, Inferno, canto XXXI, pen and watercolor, 1824, National Gallery, Melbourne.

HELL.Canto 31

■ Ludwig van Beethoven (1770–1827) composed the *Ninth Symphony* while Goya was completing his "black paintings".

Beethoven, the Titan

Born in Bonn, Germany, Beethoven soon won the admiration of the Viennese aristocracy. He composed nine symphonies – as opposed to the forty-nine by Mozart – into which he poured his very soul. Such intensity required a titanic commitment as well as exceptional technical ability. His sorrow-laden life seemed to echo that of the world; and his heroic courage in trying to combat those sorrows mirrored mankind's struggles against adversity.

123

The Bulls of Bordeaux

Printed towards the end of 1825, these lithographs were of unparalleled technical brilliance and expressiveness. Financially, however, they proved a disaster for the artist.

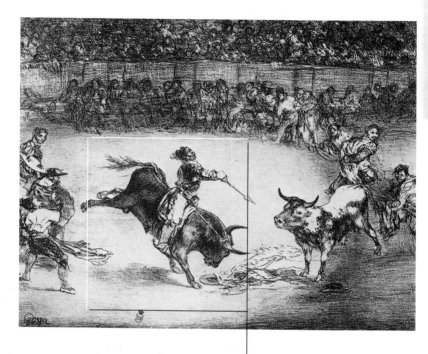

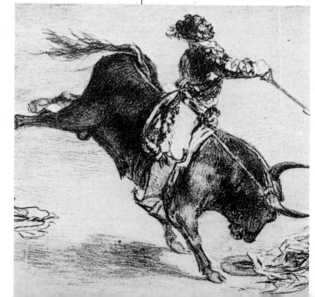

■ *The famous American Mariano Ceballos*. Goya reworks a scene from plate 24 of the *Art of Bullfighting*, but handles it quite differently. Here the well-known *torero*, probably an Argentinian, is embroiled with two high-spirited beasts.

■ *The enraged bull, or indeed the wounded picador.* This lithograph echoes a theme from plate 32 of the *Art of Bullfighting*.

■ *Entertainment in Spain.* Ever a patriotic Spaniard, Goya's love for bullfights never leaves him. Here he demonstrates the collective madness of the spectators who jump into the ring and imitate the bullfighters.

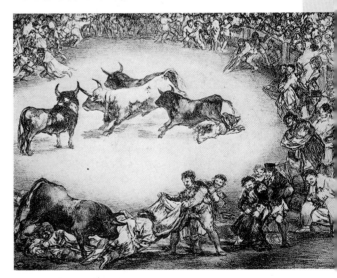

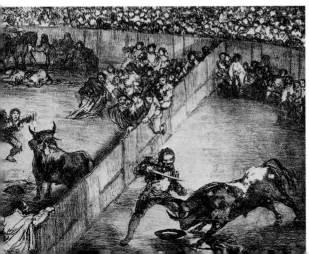

■ *The Divided Ring.* Differing styles of bullfighting take place in the two areas of the arena. In one, the bull is killed without a "*muleta*"; and in the other, *banderillas* are thrown at him. In other versions of this scene, Goya altered certain details of the composition.

1824-1828

The final embers

The artist, now in his eighties and in self-imposed exile in France, refuses to submit to the idea of dying, even though it is fast approaching. He remains full of passionate emotions, particularly about his work. The tribulations of his life have scarred, but not broken him. He has been betrayed by his body, but not his mind, which remains lucid to the end, and he faces the final months with courage. On January 17, 1828 he writes to his son that he is ill; on March 28 his grandson Mariano joins him. Then on April 1 Goya pens his final letter to Javier: "May God grant that I see you ... and then my happiness will be complete". The following day he suffers a total paralysis. He passes away the night of April 15, surrounded by his family and his dearest friends. The proud man of Aragon, who contributed so much to the birth of modern art, returned to his beloved Spain on November 29, 1919. The French poet Baudelaire wrote about Goya: "In Spain, an extraordinary man has opened new comic horizons for us [...]. Goya often plunges into savagery or soars into comic brilliance. He is at all times a great artist and often a terrifying one.... No-one has ventured further into the realm of the absurd than he has."

■ Goya, *Juan Bautista de Maguiro*, 1827, Museo del Prado, Madrid. De Maguiro was among Goya's friends during his sojourn in Bordeaux. The painting became more than a portrait of a friend, it turned into the personification of a city gentleman.

■ Goya, *Old Man on a Swing*, 1824–28, New York Hispanic Society. In this sketch, rendered with just a few lines of black chalk, an old man indulges in a childhood pleasure. It is an innocent pursuit made to appear grotesque.

■ *If Day Breaks, We Go*, plate 71 of the *Caprices*, 1797. A group of witches get together in order to meet the devil. With the first light of day they will be off, just as nightmarish visions vanish with the dawning of the new day.

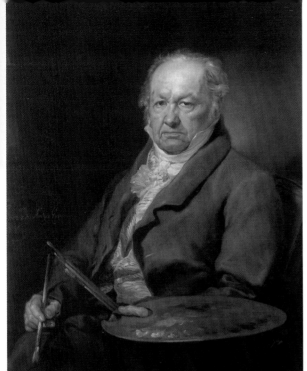

■ Vicente López, *Portrait of Francisco Goya*, 1828, Museo del Prado, Madrid. This is one of the few existing portraits of Goya. It is said that Goya himself had a hand in its execution, and instructed Lopez to stop when he considered the painting was complete.

■ *Till Death*, plate 55 of the *Caprices*, 1797. The old crone would try anything to be beautiful! Sadly, all she succeeds in doing is making the maid and the two young men behind the mirror burst into laughter. Goya seems to be implying that old age should be dignified.

Individual freedom and collective freedom

■ Charles Baudelaire (1821–1867) was one of the leading cultural figures of the mid-19th century. He represented a new type of man, one who embraced life by challenging death.

Man, having been set free to explore his long-repressed feelings and perceptions, set about discovering Nature and his surroundings with a new intensity. He experienced happiness and sorrow to the full; he gave vent to reflection and passion without the limitations of rational thought and experience. The poet Charles Baudelaire, like his Italian counterpart Giacomo Leopardi, lived a troubled life and came to symbolize the era. He struggled to explore his being, to affirm life and the meaning of his own existence, crossing boundaries that at times threatened to destroy him. In the world of politics, too, there was great turmoil. Against the tradition of conservatism and a ruling aristocracy, a new liberalism was starting to emerge. The Romantic movement propounded the concept of territories in which people would be identified on the basis of language, culture, and religion; power would be shared by all in the name of freedom. Around 1830, liberalism started to make important gains and, despite setbacks in Spain, Portugal, and Italy, the future seemed full of promise. The rapid development of industry brought about new initiatives, in particular the Universal Exhibitions which displayed the progress of science and technology. The Great Exhibition in London in 1851 was followed by other similar displays in major cities around Europe.

■ Giacomo Leopardi was among the foremost Romantic poets (1798–1837). In 1828 he wrote one of his most beautiful *Cantos, To Sylvia.* It was dedicated to the memory of Teresa, the daughter of the family coachman at Recanati, who had died tragically at the age of twenty.

■ In his own way, Giacomo Leopardi was a man who valued suffering as a means of spiritual growth. He looked both at the past and within himself for strength which he could share with his fellow man. To him nature was a malevolent force, and life was an endless but uplifting struggle against hardship and pain.

Eugène Delacroix

Considered the founder of French Romanticism, Delacroix was born into the upper-middle class. His friendship with fellow-artist Géricault proved invaluable to his artistic development since he learnt from him the importance of light and color, and a style of painting which was sincere rather than academic. Delacroix is noted particularly for his historical paintings and those relating to his travels. He was also a prolific writer, penning numerous essays on art. His painting, *Massacre at Chios* (1823–25), was strongly criticised by the Academy of Arts for its overly realistic handling of the war between the Turks and the Greeks. In politics, however, Delacroix remained staunchly conservative.

■ Eugène Delacroix, *Liberty Guiding the People*, 1830, Musée du Louvre, Paris. Painted in celebration of the revolution that restored Louis Philippe to the French throne, this work has been described as "the first political painting in the history of modern art".

■ Eugène Delacroix, *Sketch based on Caprices no.8*, pen, ink, brown watercolor and crayon, Musée du Louvre, Paris. Goya's work aroused great interest among the Romantics.

■ In 1832 Republican patriot Giuseppe Mazzini published the first issues of his newspaper *The Young Italy*.

129

The Milkmaid of Bordeaux

Goya was eighty-one when he painted
this extraordinary piece, now in the Prado
Museum. He must have known how good it
was since he instructed Leocadia never to
sell it for less than an ounce of gold.

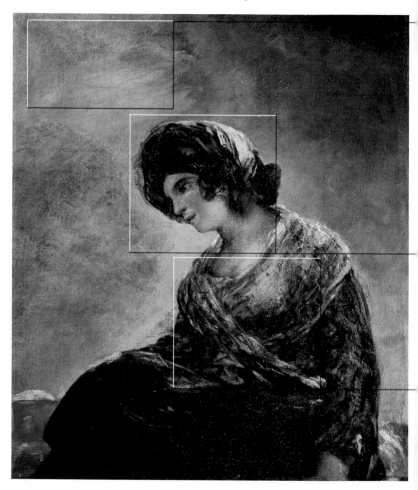

■ The background is intangible; a veil of color creates a hazy atmosphere which frames and highlights the rounded figure of the girl. The artist's mastery here is unprecedented for his time.

■ The identity of this young woman is unknown, but it is of little consequence. Her sweet face with its rosy complexion, crowned by a mass of curls and a sparkling bonnet, secures its place among Goya's finest portraits of women. His use of light and relaxed handling of paint anticipates some of the achievements of the Impressionists.

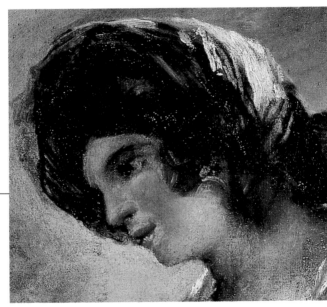

■ The light strikes the fabric of the shawl and is diffused by the fibres, making it appear transparent. Goya watched the milkmaids passing his house "on their donkeys". Perhaps one of them inspired this mysterious figure, a symbol of beauty, which he painted with such passionate abandon.

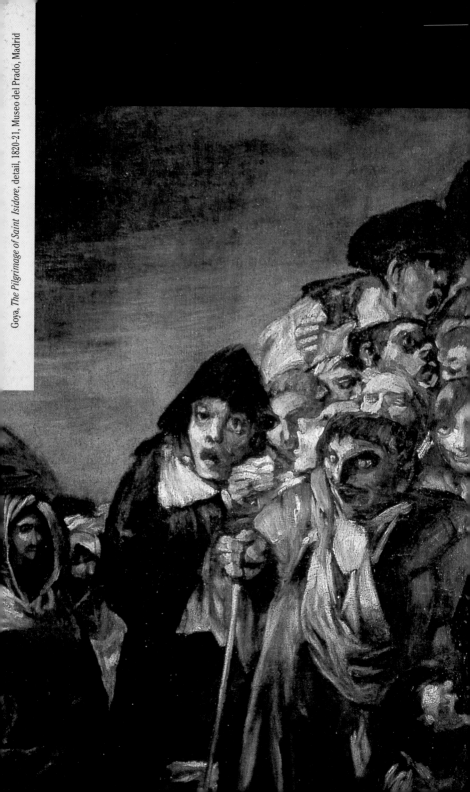

Goya, *The Pilgrimage of Saint Isidore*, detail, 1820-21, Museo del Prado, Madrid

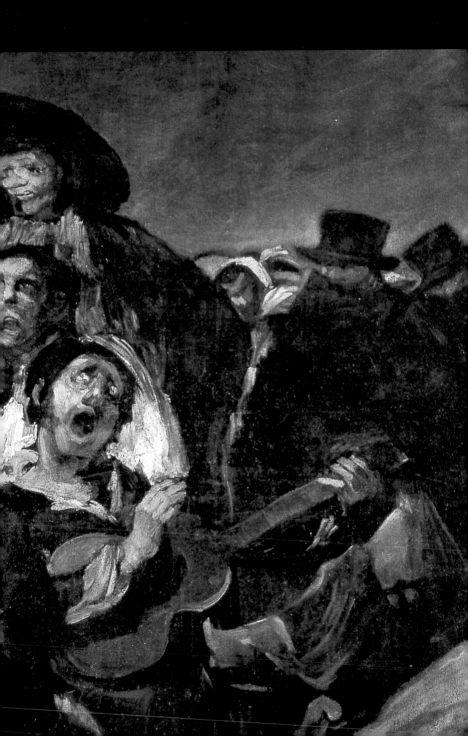

Note

The places listed in this section refer to the current location of Goya's works. Where more than one work is housed in the same **place***, they are listed in chronological order.*

Locations for Goya's prints and engravings are not listed as they are too widespread to mention. A large number of his prints, however, are on display in both public and private collections.

Barcelona, Museo de Arte de Cataluña,
Cupid and Psyche, p. 52.

Buenos Aires, Museo Nacional,
Procession of Flagellants, p. 90.

London, National Gallery,
The Devil's Lamp (The Bewitched), p. 57.

Madrid, Academia de San Fernando,
Scenes from a Prison (Lunatic Asylum), p. 43;
The Tyrant, pp. 54–55;
The Burial of the Sardine, p. 83;
Self-portrait, p. 107.

Madrid, Academia de Historia,
Charles IV, p. 39;
Maria Luisa, p. 42.

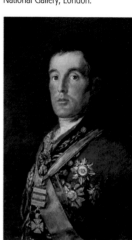

■ Goya, *The Duke of Wellington*, 1814, National Gallery, London.

Madrid, Ayuntamiento,
Allegory of the City of Madrid, p. 77.

Madrid, Banco Urquijo,
Count Floridablanca, with Goya

■ Goya, *Doña Isabel de Porcel*, 1805, National Gallery, London.

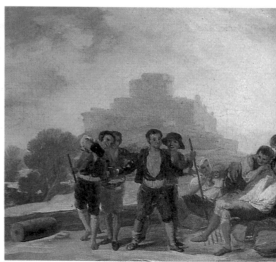

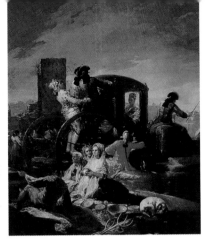

■ Goya, *The Crockery Merchant*, 1799, Museo del Prado, Madrid.

■ Goya, *The Straw Mannequin*, 1791–92, Museo del Prado, Madrid.

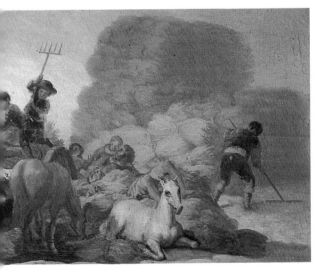

■ Goya, *Summer*, 1786, Museo Lázaro Galdiano, Madrid.

■ Goya, *Self-portrait,*
1793–95, private
collection, Madrid.

Madrid, **Museo
Lazaro Galdiano,**
*The Witches' Sabbath (The
Great He-Goat),* p. 57.

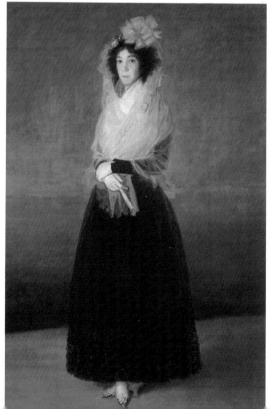

■ Goya, *Marquesa de
la Solana,* 1794–95,
Musée du Louvre, Paris.

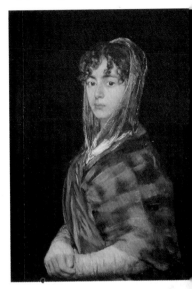

Note

All the names mentioned here are artists, intellectuals, politicians, and businessmen who had some connection with Goya, as well as painters, sculptors, and architects who were contemporaries or active in the same places as Goya.

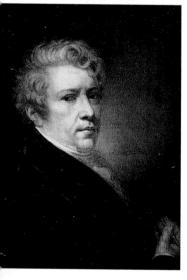

■ Andrea Appiani, *Self-portrait*, c.1810, Galleria d'Arte Moderna, Rome.

Arrieta, friend and physician of Goya, he looked after him with great care during his stay at "Quinta del Sordo" near Saint Isidore in 1819. Goya painted the two of them together in his famous work of 1820, now housed in Minneapolis, pp. 92–93, 94, 98–99.

Appiani, Andrea (Milan, 1747 – 1817), artist and protagonist of Neoclassicism. He paid homage to Napoleon in his frescoes for the royal palace in Milan, pp. 65, 72, 73.

Baudelaire, Charles (1821–1867), French poet whose work, *Les Fleurs du Mal* (1857), revolutionized European poetry by opening the doors to symbolism. He praised Goya's innovative talents in his *Writings on Art*, pp. 126, 128.

Bayeu y Subías, Francisco (Saragossa, 1743 – Madrid, 1795),

teacher and protector of Goya, he became Court Painter during the reign of Charles III. From 1788 onwards he was Director of the Academy, pp. 8, 12, 16, 20, 28.

Bayeu y Subías, Josefa, the sister of Francisco, she married Goya in 1773 and bore him six children, p. 16.

Bayeu y Subías, Ramón (Saragossa, 1746 – Aranjuez, 1793), painter and engraver, and brother of Francisco and Josefa. From 1776, he worked with Goya,

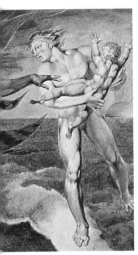

executing a large number of cartoons for the Royal Tapestry Factory, p. 36.

Beethoven, Ludwig van (Bonn, 1770 – Vienna, 1827), a composer renowned for his dark and intemperate moods, whose life was besieged by difficulties. In his mid-twenties he was afflicted with a form of deafness which gradually left him totally without hearing. He was deeply concerned with humanitarian ideals and expressed in his music a spirituality already Romantic in style. His compositions which ranged from orchestral pieces and chamber music to vocal works and pieces for the piano are among the most extraordinary ever written, pp. 58, 123.

Blake, William (London, 1757 – 1827), poet, engraver, and artist. In 1784 he started an engraving

business, printing his own illustrations. His watercolors for Dante's *Divine Comedy* are famous, p. 123.

Charles III (1716–1788), son of Philip V, he was Duke of Parma and King of Naples and Sicily before rising to the throne in Spain (1759). Part of an intellectual elite, he was considered an enlightened despot. He was one of Goya's patrons, pp. 10, 17, 20, 30, 42.

Charles IV (1748–1819), an ineffectual ruler, he allied himself to France during the revolution and ended up being one of Napoleon's pawns in his war against England, pp. 38, 39, 44, 62, 70, 76.

Canova, Antonio (Possagno, 1757 – Venice, 1822), sculptor and one of the greatest exponents of Neoclassicism. He was a favourite of the Church and of Napoleon, to whom he dedicated many works, pp. 52, 64, 72, 88, 108.

Cayetana de Silva, Maria Teresa, the Duchess of Alba, one of Goya's patrons and his suspected lover around 1795. Goya made a number of unforgettable portraits of her, pp. 50, 56, 70.

Constant, Benjamin (1767–1830), French politician and writer, and friend of Madame de Staël. A man of liberal views, he was opposed to Napoleon and then to the restoration of the monarchy. He wrote political tracts and a famous psychological novel, *Adolfo* (1816), p. 88.

David, Jacques-Louis, (Paris, 1748 – Brussels, 1825), artist influenced by Italian classicism. He took part in the Revolution and became First Painter to Napoleon, paying homage to him in a number of portraits, pp. 39, 44, 45, 53, 59, 72.

Delacroix, Eugène (Charenton-St-Maurice, 1798 – Paris, 1863), painter and engraver, foremost exponent of French Romanticism. He created intense

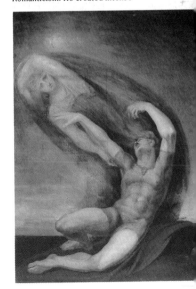

images with a richness of color which were to play a part in the birth of Impressionism. Like other Romantic artists, he was greatly influenced by Goya, p. 129.

Ferdinand VII, son and successor to Charles III. In 1808 he was usurped by Joseph Bonaparte, but reinstated as king in August 1814. A repressive ruler, he rejected the liberal Constitution of 1812 and went back to absolute rule, pp. 76, 82, 114.

Fernández, Maria del Rosario, a famous Spanish

■ Théodore Géricault, *Morning: Landscape with Fishermen*, 1818, Neue Pinakothek, Munich.

actress nicknamed "the tyrant". Goya painted her in 1799, pp. 54–55.

Fragonard, Jean-Honoré (Grasse 1732 – Paris 1806), 18th-century French artist who epitomized the spirit of Rococo. He was renowned for his marriage of eroticism and gallantry, p. 14.

Friedrich, Caspar David (Greifswald, 1774 – Dresden, 1840), among the first and foremost German Romantic painters. His landscapes were characterized by a profound sense of solitude, pp. 78, 89.

Fuseli, Henry (Zurich, 1741 – London, 1825), Swiss painter and art historian. His literary and artistic output when he was in England was to have a marked influence on William Blake, p. 31.

Géricault Théodore (Rouen 1791 – Paris 1824), French painter, engraver, and sculptor. During his travels in Italy he studied the work of artists such as Michelangelo, Caravaggio, and the Mannerists, acquiring from them their characteristic use of light, p. 97.

Giaquinto, Corrado (Molfetta, 1703 – Naples, 1765), although

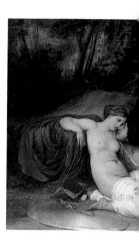

born in Italy, he was Court Painter in Madrid from 1753 to 1762, p. 16.

Godoy, Alvarez, Spanish minister who was the favourite of Queen Maria Luisa and hated by the people. His sympathy with Napoleon led to his eventual exile, pp. 63, 66, 76.

Goycoechea, Gumersinda, the wife of Javier Goya and mother of Goya's adored grandson Mariano, p. 70.

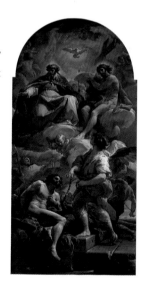

■ Corrado Giaquinto, *The Trinity and the Redeemed Slaves*, 1741– 44, Santissima Trinità degli Spagnoli, Rome.

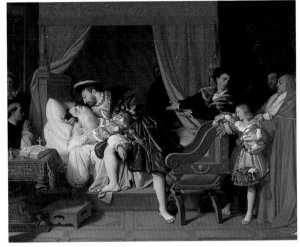

INDEX

■ Peter Paul Rubens, *Adoration of the Shepherds*, c.1605, Pinacoteca comunale, Fermo.

■ Giambattista Tiepolo, *The Triumph of Venus*, c.1760, Museo del Prado, Madrid.

also for his dreamlike images of the imagination, p. 58.

Wellington, Duke of (1769–1852), British politician and commander. In 1808 he led the English forces against the Napoleonic forces in Spain. Goya painted him many times, p. 82.

Winckelmann, Johann Joachim (Stendal 1717 – Trieste 1768), German art historian and archeologist who was considered the founder of scientific archeology and one of the forebears of 19th-century Neoclassicism, pp. 12, 14, 15, 31.

Zapater, Martín y Clavería, childhood friend of Goya, he kept up a lively correspondence with him for over twenty-five years. Goya painted his portrait around 1797, pp. 8, 28, 40, 42, 44, 45.

Zorrilla, Leocadia, Goya's young companion when he was

Velázquez, Diego Rodriquez de Silva y (Seville 1599 – Madrid 1660), influenced by Caravaggio and Spain's most renowned painter. He was Court Painter in Madrid under Philip IV and executed many important works for him as well as numerous unforgettable portraits, pp. 12, 13, 20, 21, 28, 29, 51, 66.

Vicente, López, Court Painter in Madrid after Goya, he rendered his famous predecessor in oils in 1828, pp. 65, 86, 120, 127.

Watteau Jean Antoine (Valenciennes 1684 – Nogent-sur-Marne 1721), French artist who married aspects of Rubens' style with the Venetian school. Known for his theatrical subjects and scenens of fashinable life;

already in his sixties. She stayed by his side right till the end. Goya entrusted to her his famous "black painting", now in the Prado Museum, pp. 86, 94, 100, 101.

■ Jean Antoine Watteau, *Studies of Female Heads*, private collection, Italy.

A DK PUBLISHING BOOK
Visit us on the World Wide Web at http://www.dk.com

TRANSLATOR
Emma Foa

DESIGN ASSISTANCE
Joanne Mitchell

MANAGING EDITOR
Anna Kruger

Series of monographs
edited by Stefano Peccatori and Stefano Zuffi

Text by Paola Rapelli

PICTURE SOURCES
Archivio Electa
Elemond Editori Associati wishes to thank all those museums and
photographic libraries who have kindly supplied pictures, and would be pleased
to hear from copyright holders in the event of uncredited picture sources.

Project created in conjunction with
La Biblioteca editrice s.r.l., Milan

First published in the United States in 1999 by DK Publishing Inc.
95 Madison Avenue, New York, New York 10016

ISBN 0-7894-4140-3

Library of Congress Catalog Card Number: 98-86753

First published in Great Britain in 1999
by Dorling Kindersley Limited,
9 Henrietta Street, London WC2E 8PS

A CIP catalogue record of this book is available from the British Library.

ISBN 075130722X

2 4 6 8 10 9 7 5 3 1

Printed by Elemond s.p.a. at Martellago (Venice)